IMAGES
of America

JACKSON COUNTY

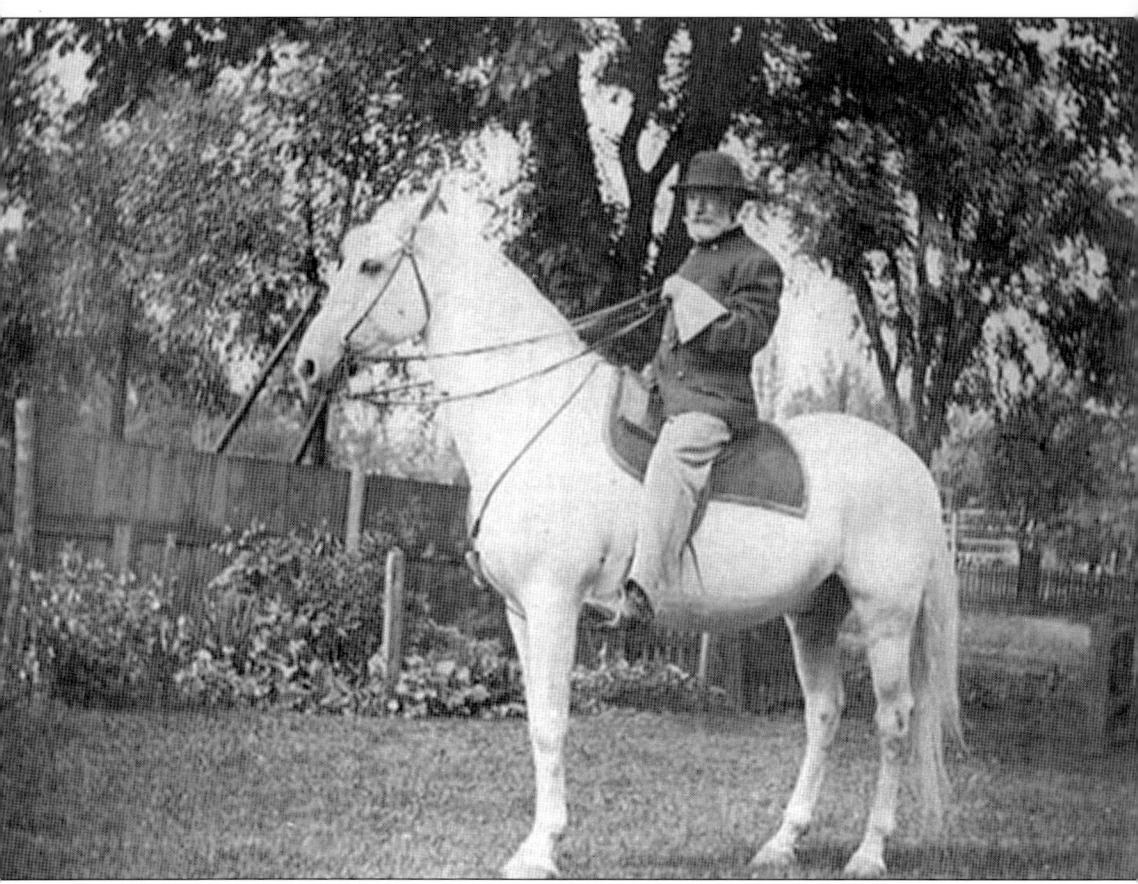

Lt. Col. Christian Rath, pictured astride his white horse, was the marshall of many Memorial Day parades in Jackson. Captain Rath, as he liked to be called, was known as a war hero and for his part in the executions of the Lincoln conspirators. He entered the Union Army on September 8, 1863, and was sent out as captain in the 7th Michigan volunteers in October 1865. He was designated a major for gallant and brave conduct before Petersburg and was afterward promoted to lieutenant colonel for special and resourceful services during the confinement, trials, and execution of the Lincoln conspirators, David Herold, George Atzerodt, Lewis Powell, and Mary Surratt. Rath supervised the building of the scaffold and carried out the details of the executions. In later years, he admitted to having nightmares from his involvement. Rath was born in Germany on October 22, 1831, and died February 14, 1920, in Jackson, Michigan. (Courtesy of the Ella Sharp Museum of Art and History.)

ON THE COVER: The No. 1 firehouse, built in 1896 on West Courtland Street between Jackson and Blackman, and its firemen are pictured around 1904. This is a view of the north side of the street. (Courtesy of the Ella Sharp Museum of Art and History.)

IMAGES *of America*
JACKSON COUNTY

Patricia Snoblen

Copyright © 2013 by Patricia Snoblen
ISBN 978-1-4671-1044-0

Published by Arcadia Publishing
Charleston, South Carolina

Printed in the United States of America

Library of Congress Control Number: 2013933330

For all general information, please contact Arcadia Publishing:
Telephone 843-853-2070
Fax 843-853-0044
E-mail sales@arcadiapublishing.com
For customer service and orders:
Toll-Free 1-888-313-2665

Visit us on the Internet at www.arcadiapublishing.com

This book is dedicated to my parents, Gerald and Josephine Snoblen; my siblings Thomas, Kathryn, Carolyn, Julie, and Elizabeth for all the support they have given me throughout the years; and to all the people who are unable to read their own handwriting.

Contents

Acknowledgments		6
Introduction		7
1.	Main Streets	9
2.	Events	19
3.	Clubs	29
4.	Work and Life	37
5.	Fun and Amusement	69
6.	Depots	83
7.	People and Places	89
8.	Wars and Militia	113
9.	Tragedies and Disasters	119

Acknowledgments

This book has been made possible by the substantial support of the citizens of Jackson County, who have cordially donated photographs, postcards, and historical materials to this author's endeavor.

Such persons and institutions that have helped make this book possible include the Ella Sharp Museum of Art and History, the Jackson District Library, Albion District Library, the Mann House Museum, the Paddock-Hubbard House Museum Foundation, the Coe House Museum, the Hanover Horton Historical Society, Spring Arbor University Archives, the Parma Township village office, Jackson Community College, and the Jackson County Genealogical Society.

Special thanks go to all the dedicated local historians, archivists, and librarians, including Judy Horn, Mickey Hardcastle, Mary Houghton, Susan Panak, Becky Cunningham, Jackie Merritt, Karen Veramy, Debbie Zeiler, David Raymond, Dan Cherry, Jeanette McDonald, Debby Sears, Elizabeth Schultz, Joan S. Ropp, Stephanie Davies, Marilyn O'Leary, Betty Jo Deforest, Jeanette Weimer, Maureen Graham, Sheridan Perrin, Rosalee Griewahn, Mary Jo VanderBos, Kathy Hawk, Liz Snoblen, Tara Botero, Marge Herman, Judy McCaslin, and Debbie Kelly.

All photographs used in this book are courtesy of the Ella Sharp Museum of Art and History except as noted.

INTRODUCTION

The Potawatomi Tribe lived in Jackson County long before Horace Blackman made his claim. The leader of the Potawatomi at the time of Blackman was Whap-ca-zeek (the Fast Runner). He and his tribe lived in the area of what is now Spring Arbor. Known for being a tall and athletically built man, he lost his leg in the battle of Tippecanoe. It was said that, with his one strong leg and a crutch, he could run like a deer.

Charles Deland states in his book *The History of Jackson County*, "There was a full company, one hundred strong, of Potawatomi's attached to the regiment I had the honor to command, the First Michigan Sharpshooters, and they were model soldiers in every respect. Their powers of endurance were of the highest order, and they were in all respects equal and in many superior, to the best soldiers."

In 1830, Pres. Andrew Jackson signed into law the Indian Removal Act, and by the 1840s, most members of the Potawatomi tribe of Jackson County were forced from their homes and moved from Michigan to Green Bay, Wisconsin. Approximately 1,500 Native Americans were collected.

The first known European settlers in the Michigan Territory were the French; they traveled to Michigan, then known as New France, in the early 16th century under the orders of King Francis I to find a new route to China for trade and missions. New France extended from the uppermost part of Canada all the way down to Louisiana. The French did not discover a new route to Asia, but they did find a land rich in natural resources and wild animals. Bear, muskrat, mink, wolf, fox, coyote, rabbit, and especially beaver were trapped for their furs and traded.

Fur trading became the major economic resource for New France, and made many of the French rich. The *Castor canadensis* (beaver) pelt was the most sought after for its water-resistant fur and hide. By the 1700s, beaver fur was so valuable that the animal was almost hunted to extinction in North America. Once trapped, the beaver's fur was processed into a waterproof felt that was then made into waterproof clothing.

Another person who arrived before Blackman was Jean Batteese Berrard, a trader and trapper who made his home and business (a trading post) on Batteese Lake in Henrietta Township during the early 1800s. He traded or sold supplies to the local tribe and to other trappers. Common supplies for such trades were guns, gunpowder, lead, and whiskey.

The completion of the Erie Canal made it easier for pioneers from the east to come west. In fact, many of the men who worked on the Erie Canal found Michigan to be an attractive place to live.

Early pioneers used the trails established by Native Americans as they traveled from Detroit to Ann Arbor and eventually to Jackson County. The Native Americans used Jackson County as a natural crossroads and a trading center. Because of its central location in the state, it continued to be a focal point for trading, and the county grew rapidly.

The first pioneers of Jackson County had a difficult time claiming their land; they had to struggle with trails that were little more than paths and which were frequently flooded or impassable,

which made traveling with wagons problematic. They also had wild animals to contend with as wolves, bears, and cougars could be found in Michigan at the time. Sickness was another major concern, and many pioneers suffered from ague, a very high fever most likely related to malaria or other diseases from mosquitoes.

With the decline of fur trading, timber became the next moneymaking venture in Michigan. Jackson County had an abundance of valuable ash, oak, hickory, maple, walnut, and tamarack trees. The clear-cutting of trees in sizeable areas facilitated the cultivation of large areas of land for farming.

By the turn of the 20th century, the county seat, the city of Jackson, was thriving. The arrival of the railroads, industry, and manufacturing created even more growth and wealth for its citizens. By this time, Jackson was known for having great statesmen, a large workforce, and many natural resources. Jackson had factories that made clothing, such as corsets, gloves, shoes, overalls, and mittens, and others that made boilers, carriages, wagons, locomotives, and railway cars. In the 1900s, Jackson also had public transportation, coal mines, large farms, a police force, and a fire department. It had a sewer system and water from artesian wells, numerous schools, churches, and social clubs, and was a city that was very desirable to live and work in.

There have been several books written on the history of Jackson County, including a couple on the illustrated history of the area. Many of these images might be familiar to you, but it never hurts to be reminded of our past. When I started this project, I was overwhelmed by all of the wonderful historical richness that Jackson, Michigan, has to offer. In writing and researching this book, I looked for photographs that might not have been published before and was again overwhelmed with all of the images that were available to me; as a result, I was not able to use every photograph I wanted to. This book could have been done in a series of several volumes with all of the information that I found. There could be a book just on the Crouch murders or a biography of Christian Rath. On a couple of occasions, I found the same picture in different institutions around the county, accompanied by conflicting information. In those cases, I investigated as much as possible to find the truth. I researched extensively at the Ella Sharp Museum and at the Jackson District Library. I would also like to state that while some people may find certain images offensive, they are nonetheless part of our history, and history is not always pleasing. If you are interested in learning more about the area, I recommend reading Charles V. Deland's *History of Jackson County*.

—Patricia Snoblen, 2013

One

MAIN STREETS

Originally, the main avenue of Jackson had no connection east or west with the territorial road, and travelers went on down Jackson Street to Trail Street, where they crossed the river and wound around east diagonally to Ganson Street. To fix this problem, Mr. Druand, a land surveyor, was asked to lay out extensions to connect with the territorial road on both the east and west side. As soon as his surveying was done, the roads were built. Later, the street was extended west to its present limits. This south-facing image of what is currently known as Michigan Avenue is one of the oldest known photographs of Jackson's main street, dating to the winter of 1866. The City Meat Market is on the left side. There was also a drugstore owned by Dr. W.W. Androws, a bookstore, a jeweler, and the law office of Austin Blair.

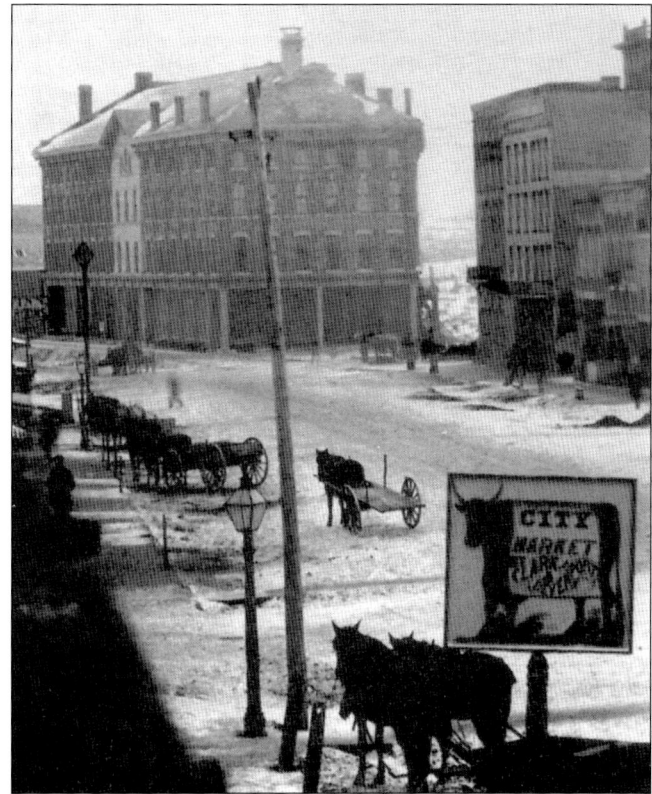

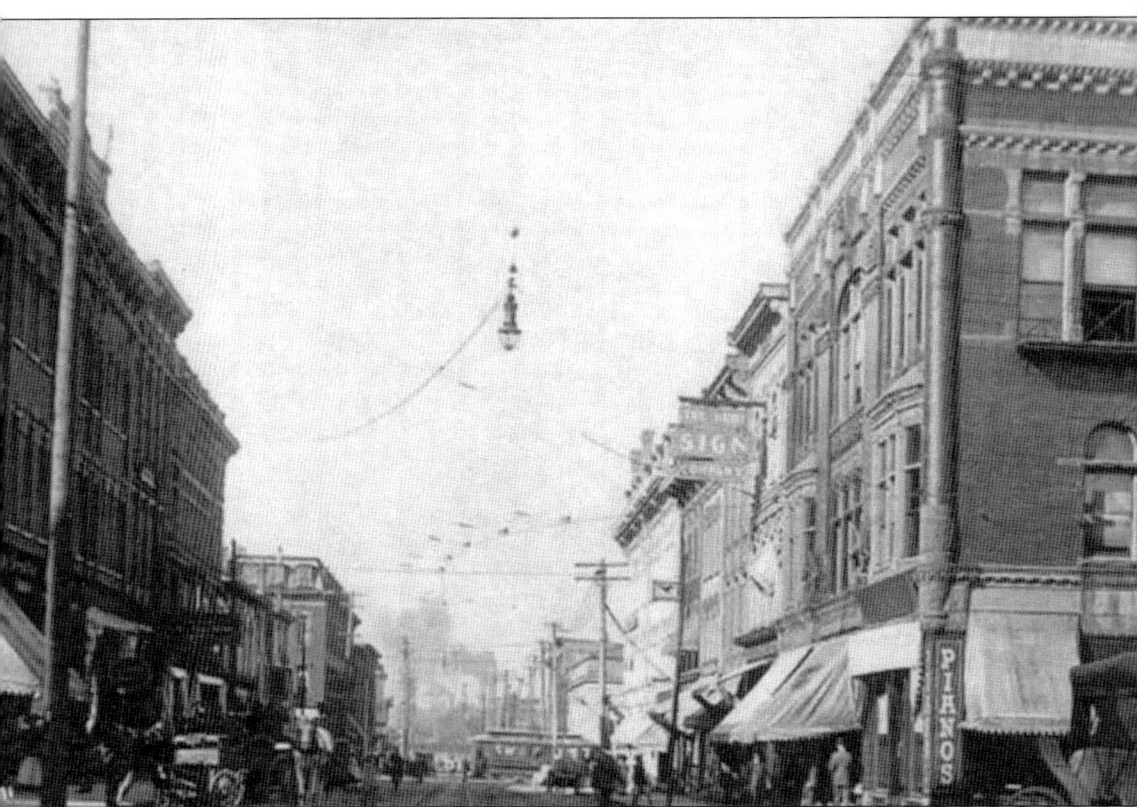
By the early 1900s, Jackson was a modern city with three- and four-story buildings, warehouses and factories, telephone service, electric streetcars, electric lighting, and a city wastewater system. Jackson thrived because of its sizeable labor force and its central location in the state. The majority of residents were skilled or semiskilled workers, and many became wealthy, which is apparent in some of the homes that were built along Wildwood Avenue and West Main Street. This photograph shows North Mechanic Street around 1900. (Courtesy of the Jackson District Library.)

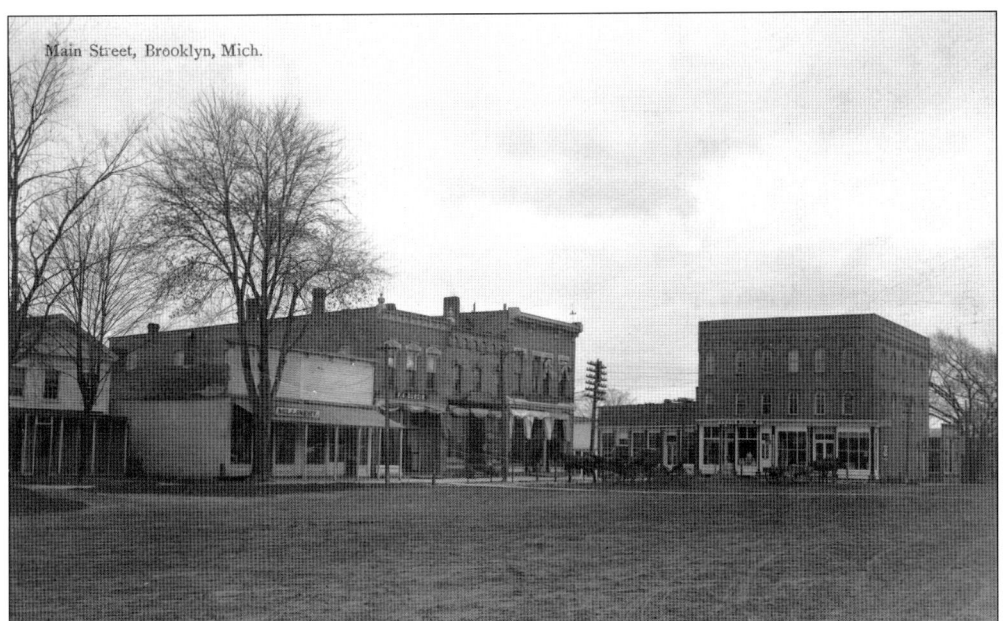

The village of Brooklyn (originally called Swainsville) was founded by Calvin Swain, who filed the first land claim on June 16, 1832. In a town vote on August 5, 1836, the community elected to change the village's name to Brooklyn. Brooklyn became known for its many beautiful lakes and picturesque landscapes. This southeastern view of Main Street dates to around 1900. (Courtesy of Dan Cherry.)

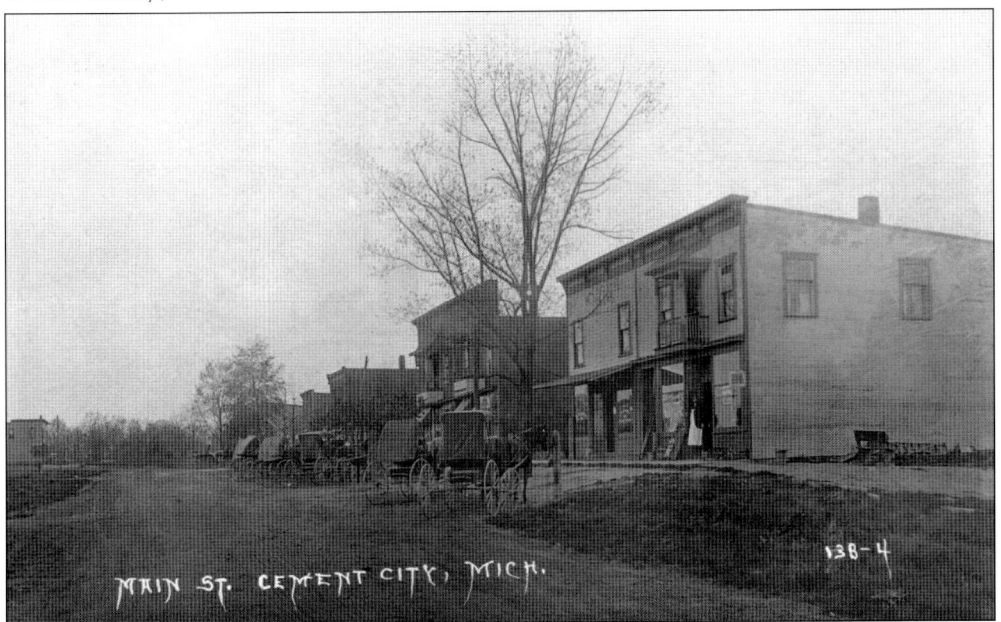

According to the *Jackson Citizen Patriot*, Cement City was originally named Kelley's Corners, and later, Woodstock. It became Cement City in 1900, named after the Peninsular Portland Cement Company. The town began near Cary and Cement City Roads and had a general store, a blacksmith shop, and a few houses. It was surrounded by farms and was named after its major industry. The town's Main Street is pictured here around 1901. (Courtesy of Mickey Hardcastle.)

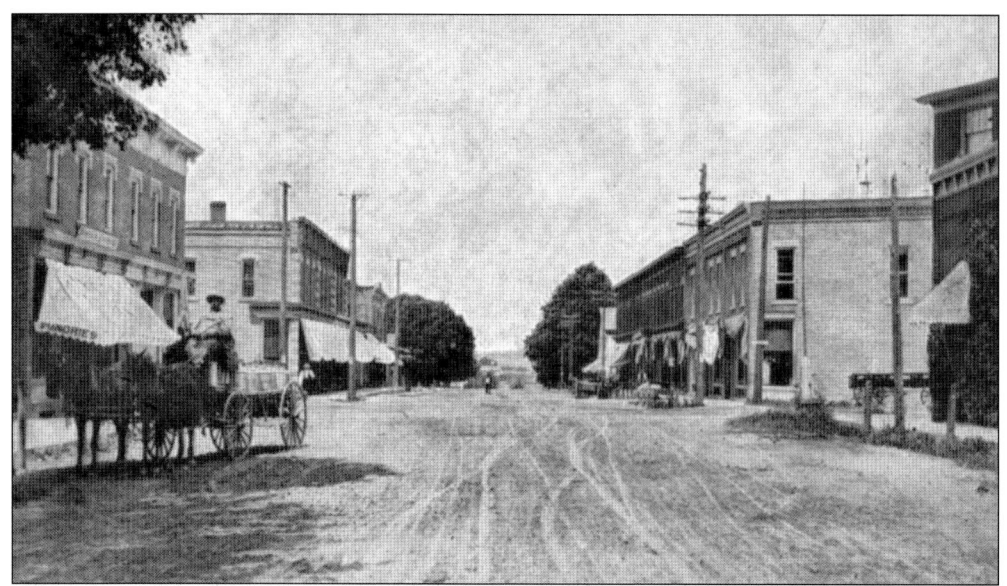

The first settler in the township of Concord was John Acker, who came with his family in November 1831. The following May, William Van Fossen came and put up his cabin. In June, Thomas McGee moved into the settlement and put up a home for his family. A colony was formed before the close of 1832, and the beginning of a community was established. Concord first received a post office in 1836 and was incorporated as a village in 1871. This view shows Concord's Main Street, facing south. (Courtesy of David Raymond.)

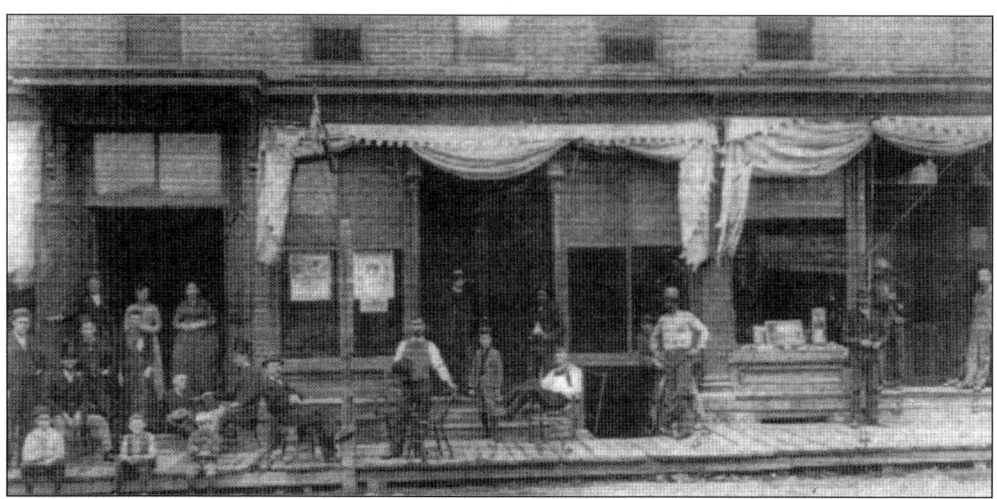

In 1836, Concord Township was still a part of Spring Arbor Township. When it was first set off into a distinct township, it included the areas of both Pulaski and Concord. In 1837, however, Pulaski was made a separate town, and the present limits of the township of Concord were established. This picture shows a couple in front of the harness shop and saloon on Main Street. The harness shop was owned by George Hungerford. (Courtesy of David Raymond.)

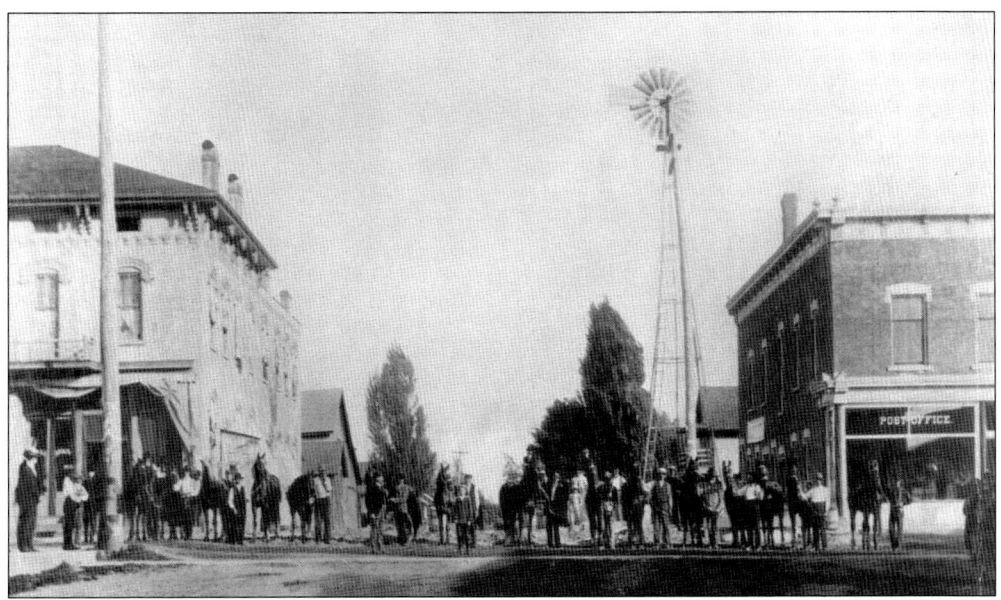

Grass Lake was first settled in the spring of 1829 by a squatter named David Sterling, who lived in his single cabin one and a half miles west of the present village. In the fall of the same year, he was followed by a party from Niagara County—George C. Pease, his son William. H. Pease, and David Thayer, a cousin. In 1830, Daniel Walker arrived from Vermont, and in 1831, he was appointed postmaster. Ralph Updike, John Ritchie, and others settled here in 1831. In this c. 1900 photograph of Main Street in Grass Lake looking west, the post office is on the right. (Courtesy of David Raymond.)

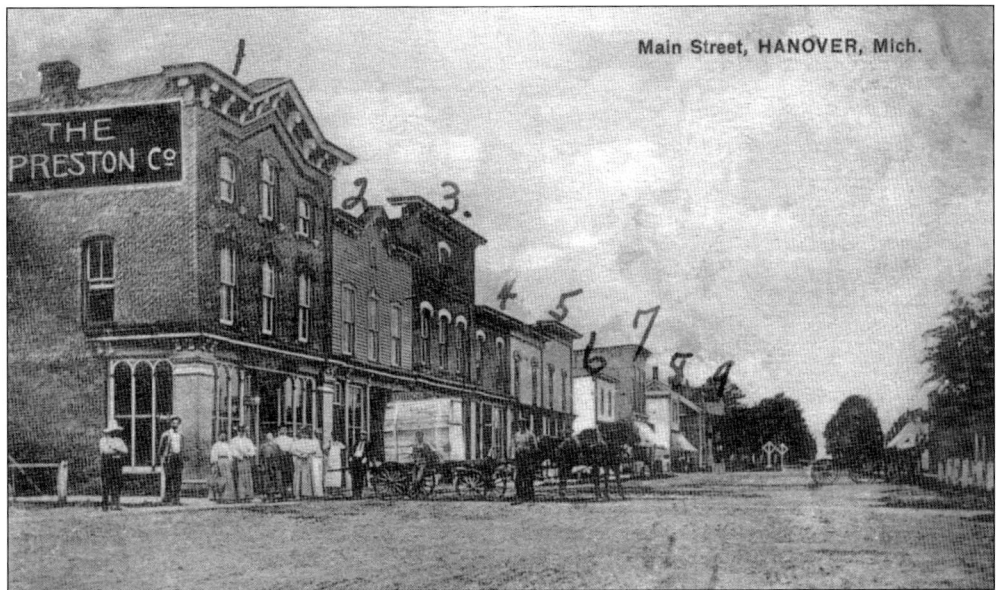

Hanover had been a part of Spring Arbor Township but was organized into a separate township in 1836. At the first township meeting, which was held at the house of Amos Brown in May 1836, Charles Parsons was chosen moderator, and Charles S. Stone clerk. Daniel Porter was elected supervisor. This 1903 view of Hanover's Main Street looks west from Spink Street. (Courtesy of the Hanover Historical Society.)

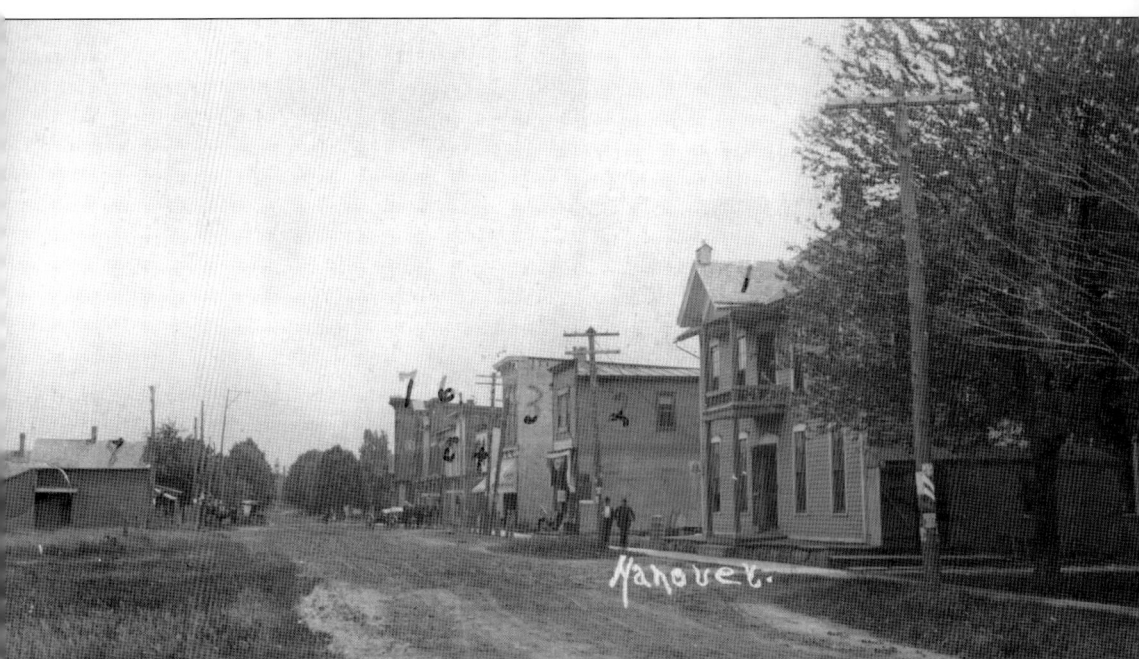

This is Hanover's Main Street in 1899 looking east, with the Hanover Hotel visible as the first building on the right. The first church in Hanover was built in 1873. The first postmaster, Mr. Crittenden, was appointed in 1836. For a number of years, Hanover experienced rapid growth, becoming a center of trade for the railroad. But in 1881, trade began to decline because the addition of a second railroad line, the Cincinnati & Mackinaw, led to the opening of too many other trading points to the east and west. A fire in 1884 consumed half the village of Hanover, and the community has never regained the volume of business that it had in the 1870s. (Courtesy of the Hanover Historical Society.)

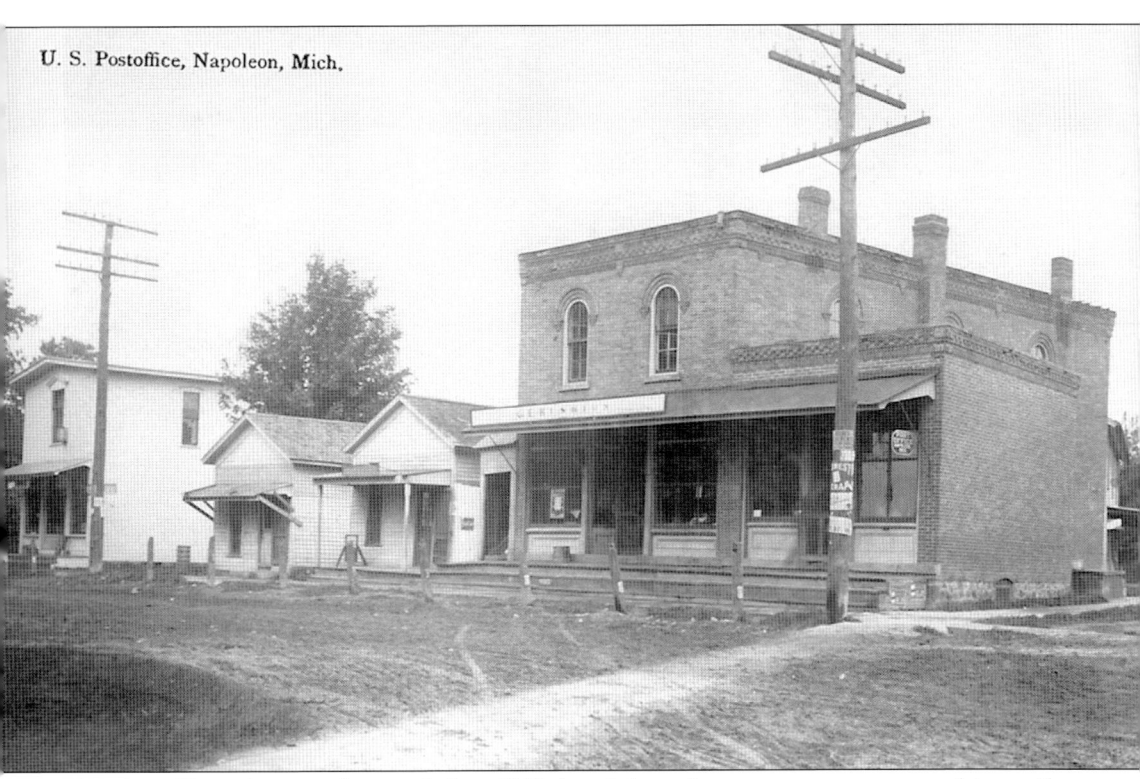

U. S. Postoffice, Napoleon, Mich.

Napoleon Township was first settled in 1832, but did not become a separate township until 1859. The first township election was held on April 4, 1859, with Roswell B. Rexford chosen supervisor, and Brian Bently town clerk. Aaron. B. Goodwin was the first settler in Napoleon village, arriving in May 1832 and bringing his wife and adopted daughter. His nearest neighbor was Charles Blackman, who had settled in Lenawee County a few years before. Blackman had taken up land in Napoleon in 1831 but did not live on it. Blackman, Goodwin, and Abram Bolton (of Coldwater) started quarrying stone from the quarry that would later be owned by Morgan Case and William Allen. The first post office was opened in December 1832 with Samuel Quigley as postmaster. (Courtesy of Dan Cherry.)

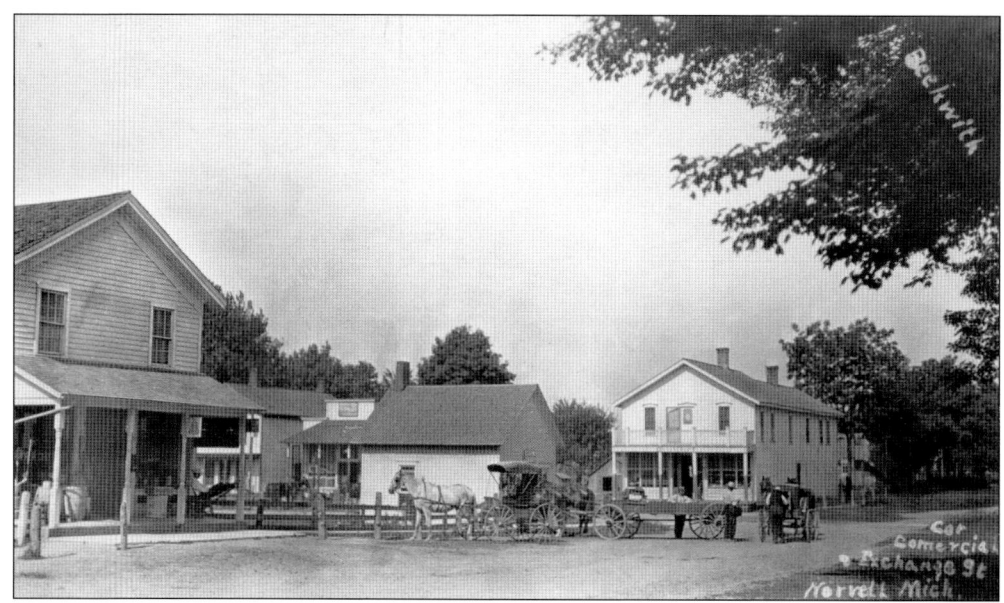

The township of Norvell is named after John Norvell, who entered the US Senate with the Jacksonian extension of the Democratic party in 1835. William Hunt, the first settler in the area, arrived in 1831. A post office was established on March 17, 1838, with Harvey Austin as the first postmaster. It was a station on the Lake Shore & Michigan Southern Railway in 1878. This view shows the commercial and exchange street in 1910. (Courtesy of Mickey Hardcastle.)

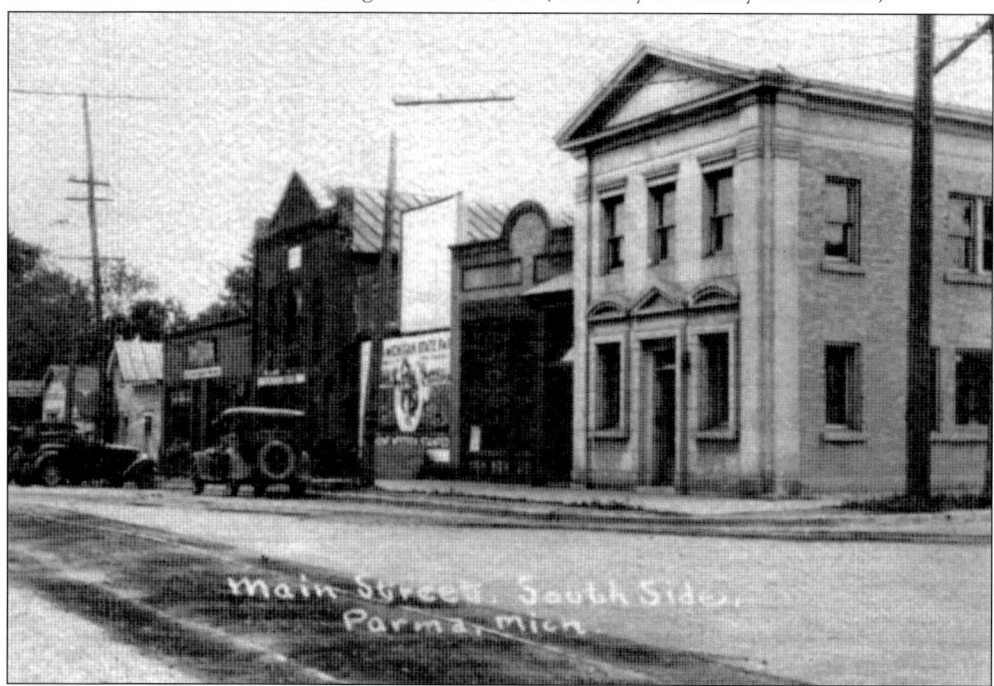

Parma was originally located a few miles east of its current location along the Michigan Central Railroad, at a stop known as Gidley's Station. When it was moved to its current site, it was called Groveland after a noticeable grove of trees within the town. When the village was incorporated in 1847, its name was changed to Parma. The south side of Main Street is seen here in 1914.

Amasa B. Gibson and Moses Bean settled in Spring Arbor Township in the spring of 1831. There were three other families there at the time—those of Isaac N. Swain, Mr. Smith, and Mr. Van Fossen. Additional settlers in this town included James Videto, L.W. Douglas, Jacob D. Crouch, and Louis Snyder. At the spring election in 1833, Gibson was elected supervisor. The present township was established in 1838. The first supervisor of the town, after its final organization, was Doctor Connell. It was here that the Pottawatomie tribe had their village. This photograph is of the Charles H. Rauch store around 1899. (Courtesy of Spring Arbor University archivist Susan Panak.)

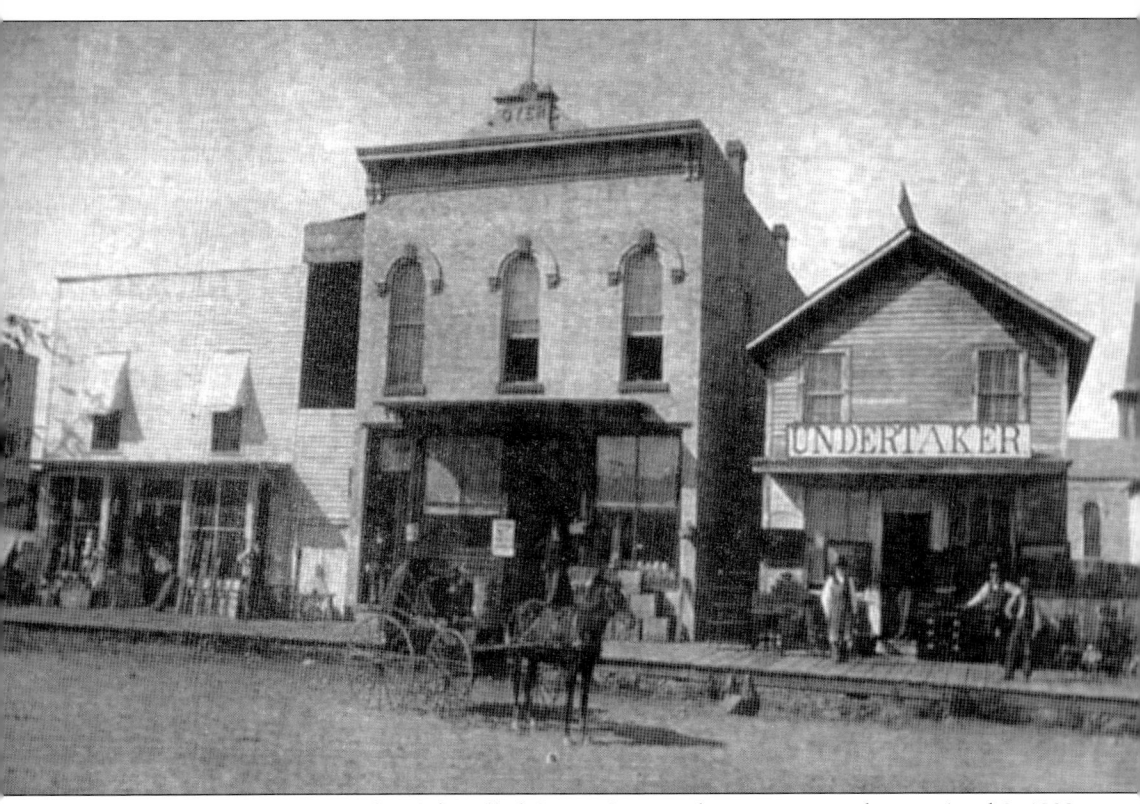

The village of Springport, formerly called Oyer's Corners, became a township on April 2, 1838. An election held at the house of Isaac B. Gates resulted in the choice of Josiah Whitman for supervisor and William V. Morrison as town clerk. The first post office was established in January 1838, with Augustus F. Gaylord as the first postmaster (a position he filled for 15 years). The Main Street location of the Springport undertaker is seen here. (Courtesy of Jackie Merritt, Springport librarian.)

Two

EVENTS

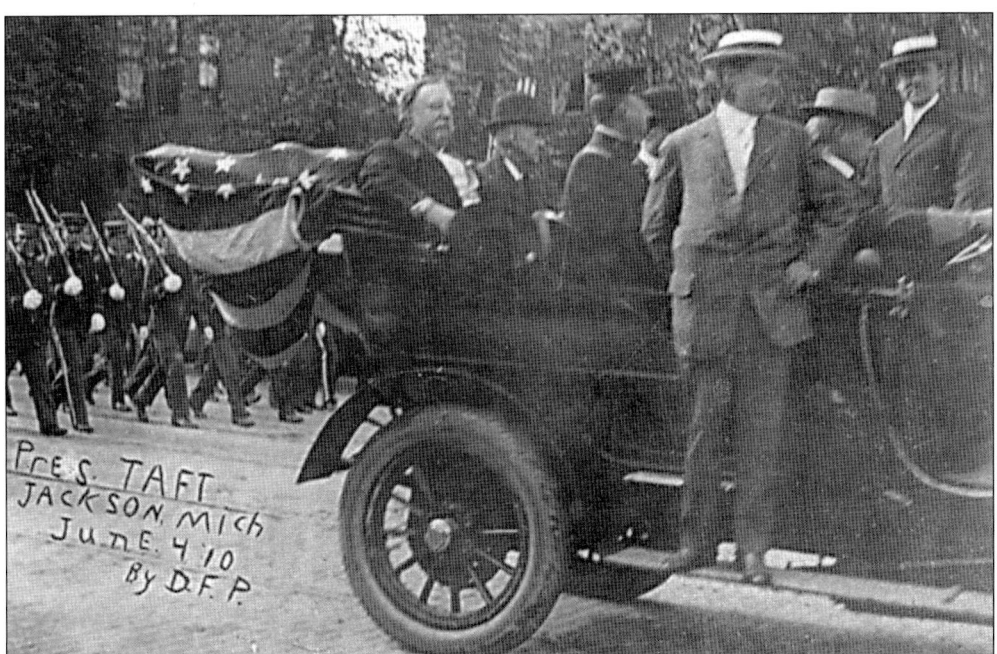

Here, Ralph Lewis drives President Taft in Leonard H. Fields's Pierce Arrow motor car for the Under the Oaks celebration on June 4, 1910. The chamber of commerce wanted to commemorate the 1854 founding of the Republican party in Jackson, and Pres. William Howard Taft, a Republican, dedicated the boulder and plaque that reads, "Here under the oaks, July 6, 1854, was born the Republican Party. Destined in the throes of civil strife to abolish slavery, vindicate democracy and perpetuate the Union."

From left to right, Charles Elroy Townsend, an unidentified citizen, and President Taft are pictured at the Under the Oaks celebration on June 4, 1910. Townsend had just recently been elected to the US Senate in 1910 and was reelected in 1916. President Taft gave a well-attended speech at the fairgrounds.

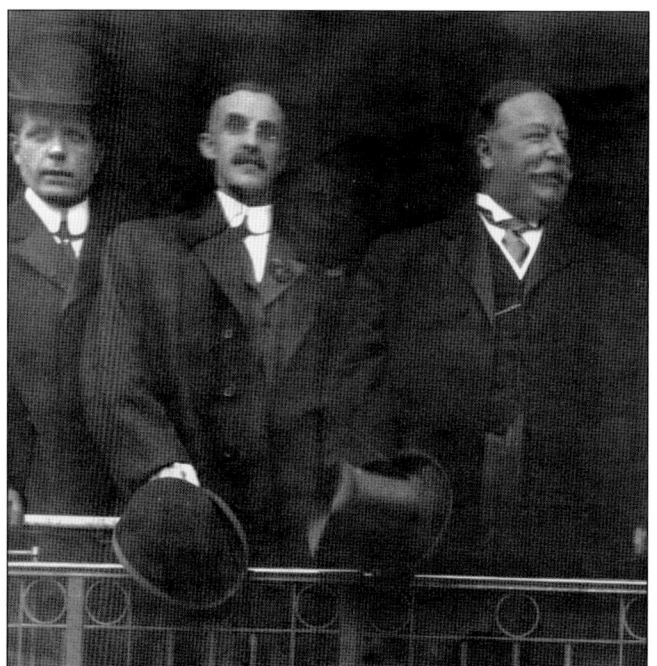

Charles Elroy Townsend and his supporters petitioned the US Senate at the Michigan capitol on August 10, 1922. His reelection was unsuccessful. Townsend was born near Concord on August 15, 1856, and attended the common schools in Concord and Jackson and the University of Michigan in Ann Arbor. He died August 3, 1924, in Jackson, Michigan.

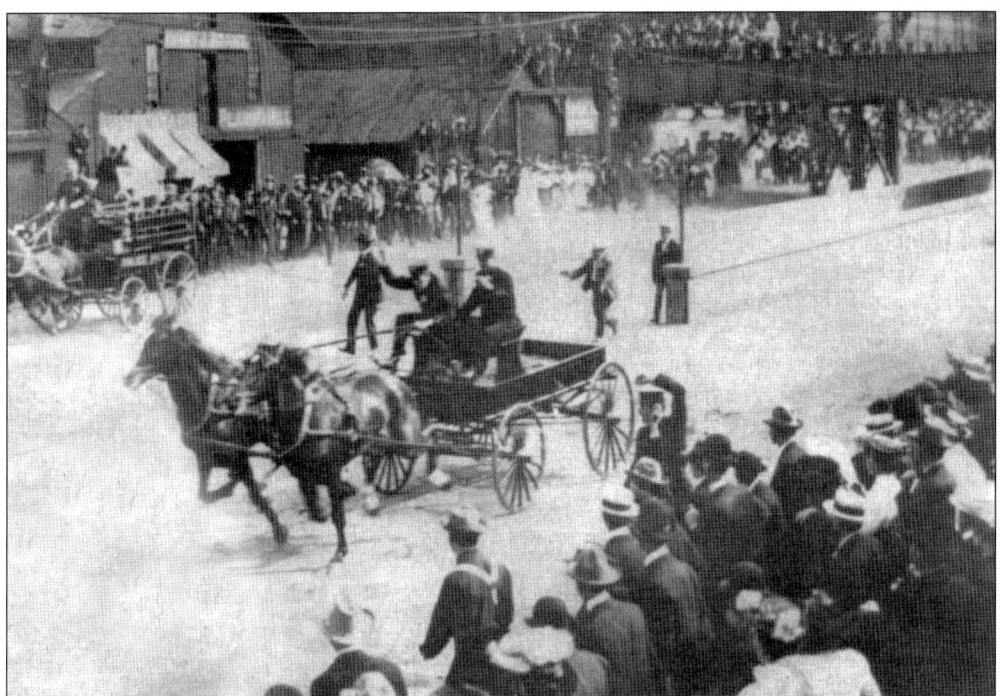

A race between the fire department and the police department on July 4, 1905, took place on North Jackson Street from Pearl Street to Ganson Street. The fire department won, and the event drew a large crowd of Jackson residents. The driver for the fire department was James Crawford.

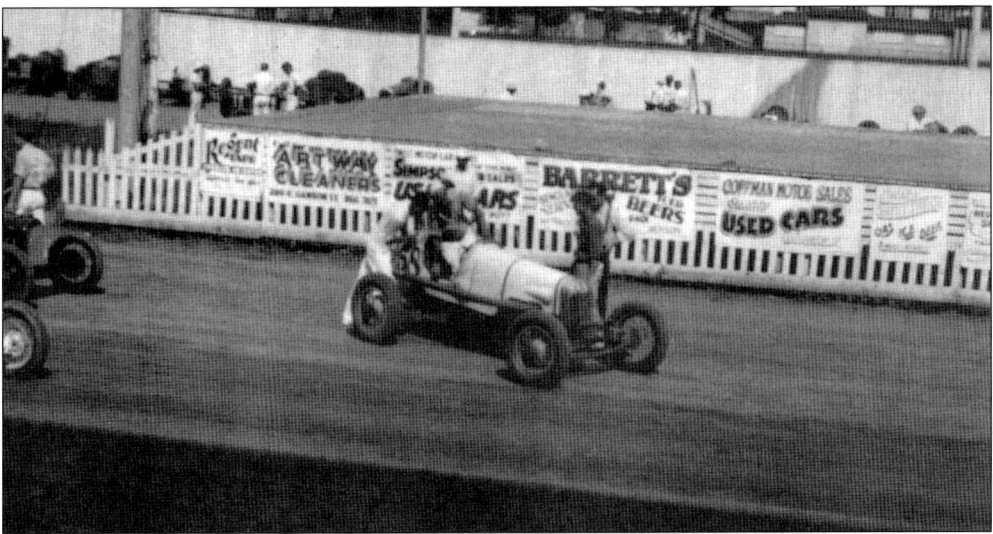

Robert "Wild Bob" Burman, in a Cutting racing car, is seen around 1912 at the Keeley Park track. Burman, born in Flint, Michigan, on April 18, 1884, came to Jackson to work for Jackson Automobile Company as a machinist. He lived at 806 West Ganson Street. While working at the Buick plant in Jackson, he was asked by the manager, William Durant, to start a racing team. Burman asked Arthur and Louis Chevrolet to join the team, and they became one of the best in the country, winning 500 races from 1908 to 1911. Robert Burman died in a road race on April 8, 1916, in Corona, California, at the age of 31. He is buried in Imlay City in Lapeer County.

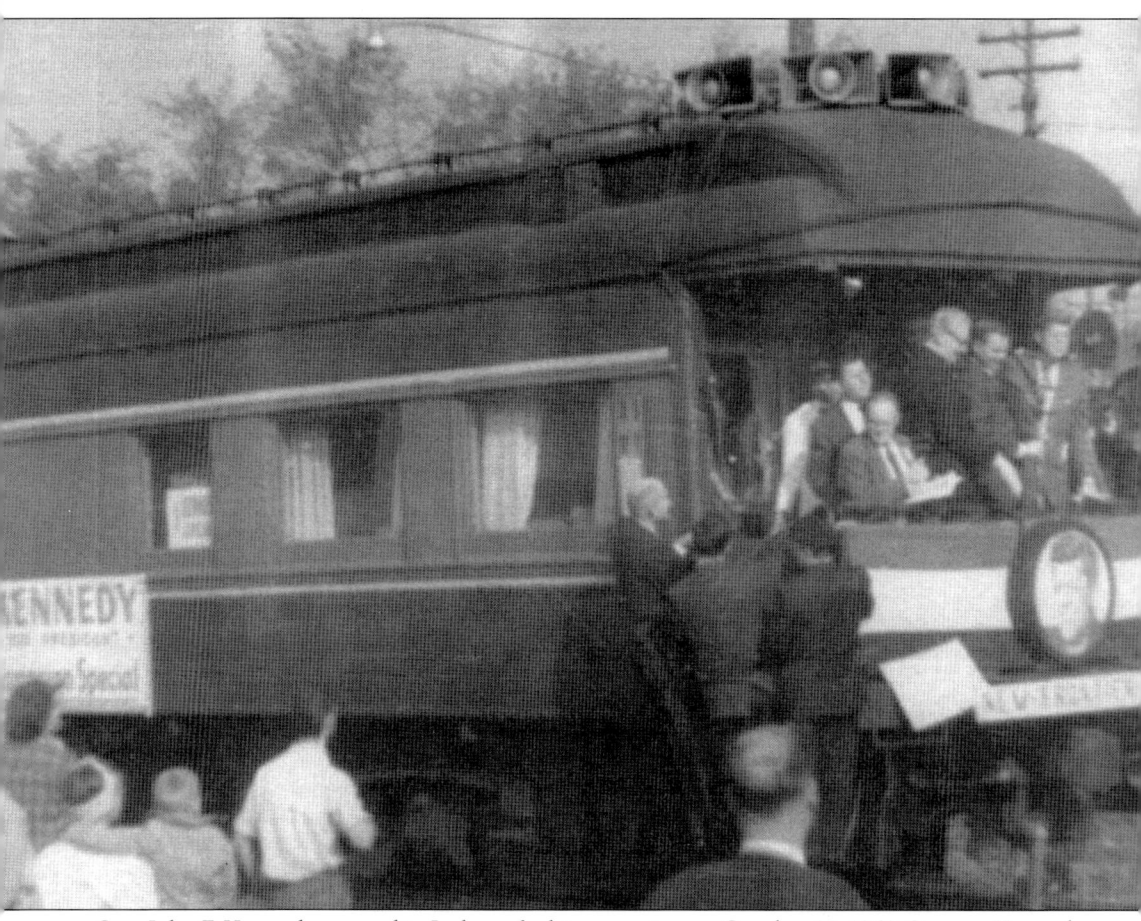

Sen. John F. Kennedy stopped in Jackson for his campaign on October 14, 1960. Senator Kennedy was running against Richard Nixon, who also stopped in Jackson during his own campaign on October 27, 1960. Although Nixon was the favorite for president in Jackson County, it was John F. Kennedy who won the election.

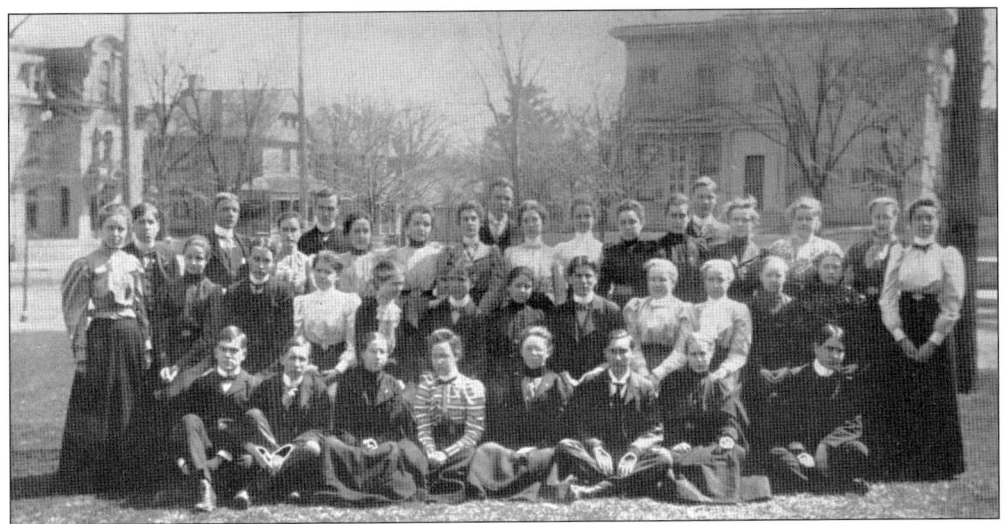

This image shows the Jackson High graduating class of 1899. The class officers were Karl H. Pratt, president; Nettie G. Hood, vice president; and William H. Buskirk, secretary and treasurer. Their motto was *Finis opus coranat*; their colors were scarlet and white, and their flowers were red and white carnations. (Courtesy of the Jackson Genealogy Library.)

The first graduating class of Jackson Junior College stands in front of Marsh Hall in 1929 or 1930. The two-year-old school was headed by Dean John Paul Jones. Marsh Hall was the original building for the institution, which is currently known as Jackson College. It stood on Wildwood Avenue west of Jackson High and was named for Edward O. Marsh Jackson, school superintendent from 1911 to 1930. A fire destroyed the building on April 2, 1956. (Courtesy of Jackson College.)

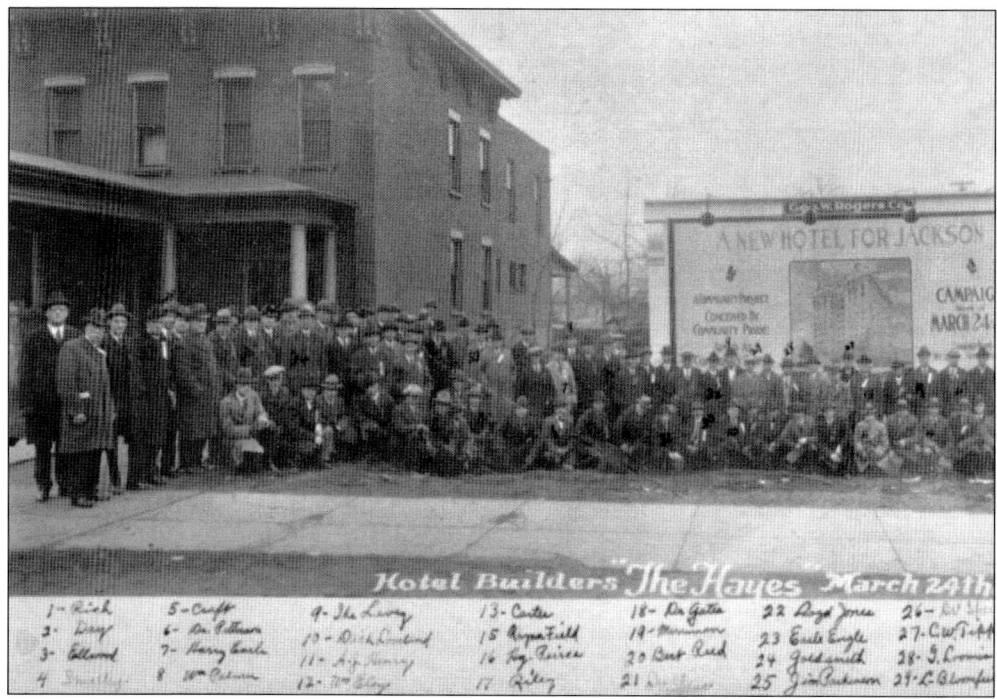

The Hayes Hotel was constructed primarily of brick and concrete. It featured over 200 rooms and suites, a luxurious lobby, and an impressive 122,000-square-foot ballroom with terrazzo flooring. It also had an upscale restaurant and lounge. The hotel was named after Clarence B. Hayes, a local man who founded the largest wheel-manufacturing company in the world—Hayes Wheel Company, which later became known as the Kelsey-Hayes Company. The Hayes Hotel closed in 1975 and the building still stands unoccupied on Michigan Avenue. This photograph of the men who built the Hayes Hotel dates to approximately 1925.

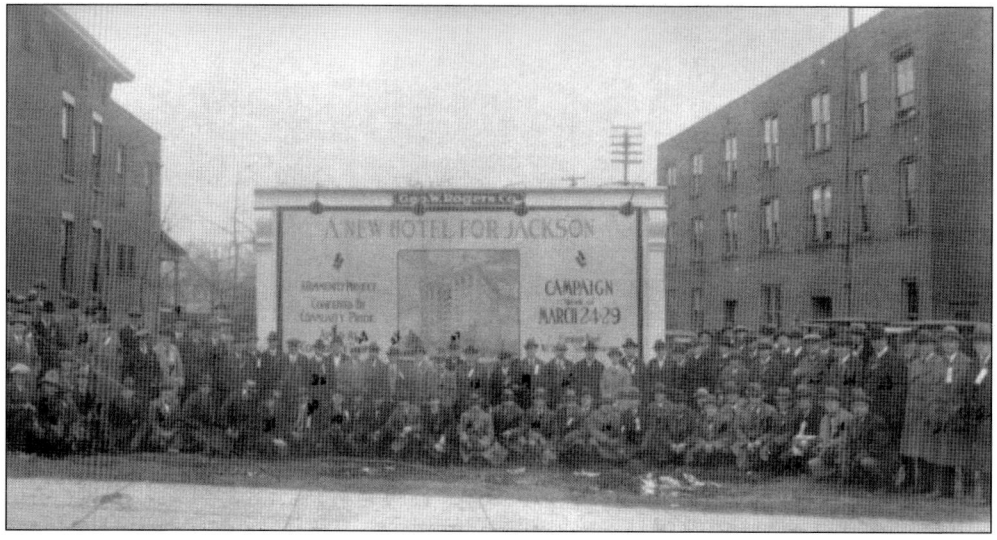

Pictured here in 1929, Boy Scouts are making the first transoceanic radio phone call between the home of Capt. William Sparks of Jackson, Michigan, and the Inter-Allied Club in Paris, France. The Scouts include, in no particular order, Edward Vandervoort, Feldher Yocum, Harold Clute, Benjamin Glasgow, William North, James Goodrich, John F. Streif, Jack Osburn, and Bogue Hunt. Also in this photograph, taken at the Inter-Allied Club in Paris, are Mademoiselle Clara Von Embden, George White, Col. Francis Drake, Mrs. George White, and an unidentified reporter for the *Daily Mail*.

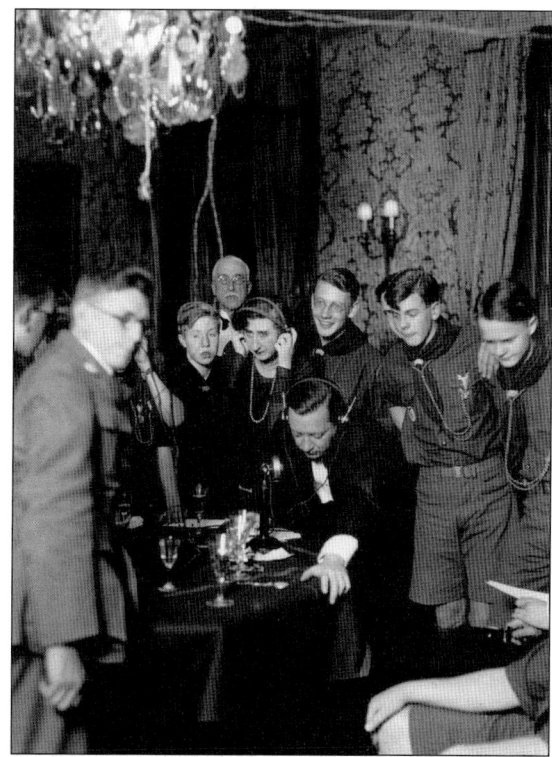

These parents of Boy Scouts are waiting for the first transoceanic phone call. They include Mr. and Mrs. Edward G. Vandervoort of 308 Webster Street, Mr. and Mrs. William H. Yocum of 616 Wildwood Avenue, Mr. and Mrs. Allie R. Clute of 716 North State Street, Mrs. Edgar Glasgow of Glasgow Farm, Leona D. North of 925 Williams Street, Mr. and Mrs. William F. Goodrich of 811 Union Street, Mr. and Mrs. A. Streif of 115 Second Street, Mr. and Mrs. J. Arthur Osburn of 1221 North Waterloo, and Mr. and Mrs. George B. Hunt of 1011 Maple Avenue.

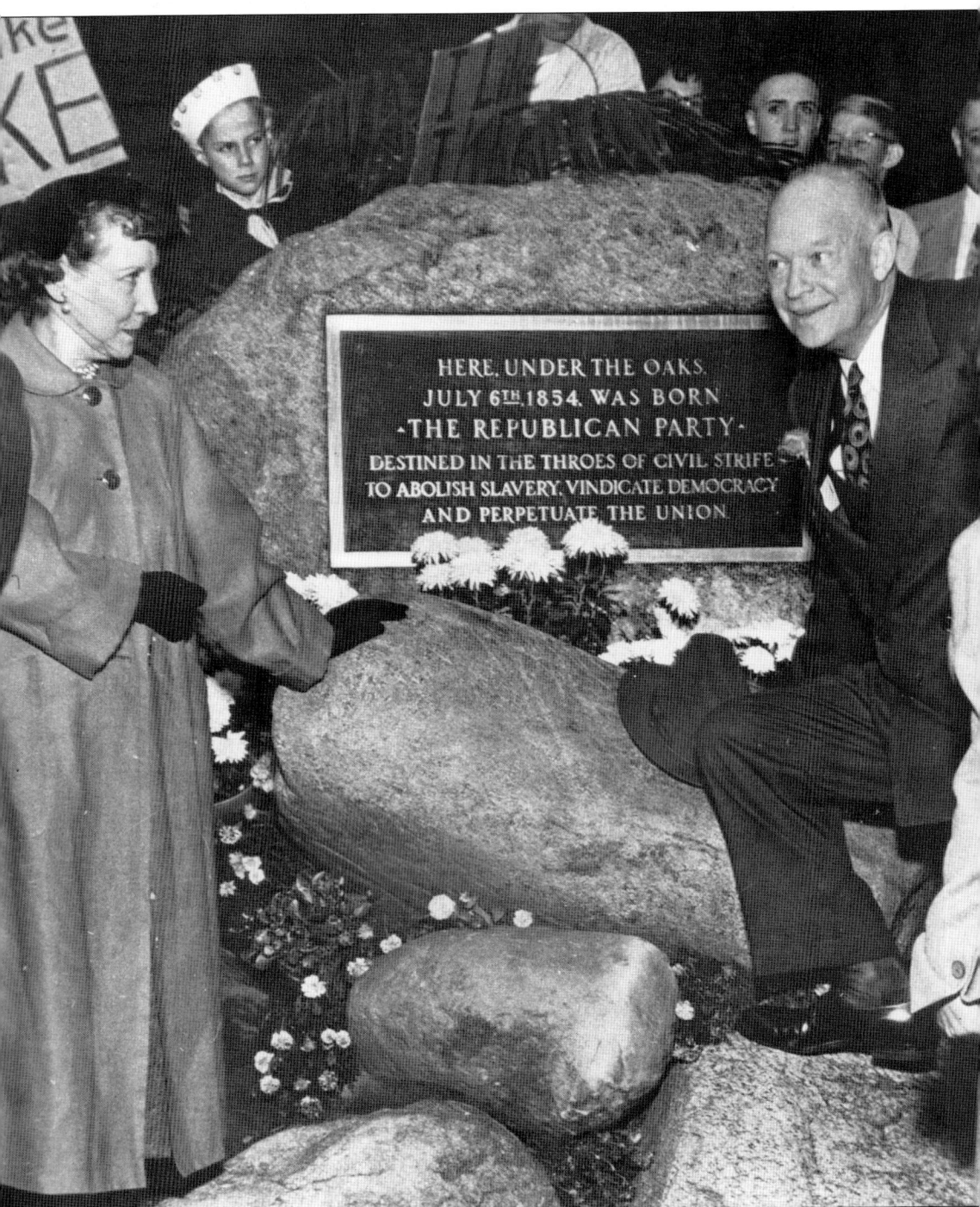

The 34th president of the United States, Dwight David Eisenhower, and his wife, Mamie, smile at the Under the Oaks monument on October 1, 1952. President Eisenhower spoke at Withington Park, where 40,000 Jackson citizens attended. Eisenhower proclaimed it "one of the finest crowds [he had] ever seen." He spoke of honesty and good government in celebration of the Republican convention of 1854 in Jackson.

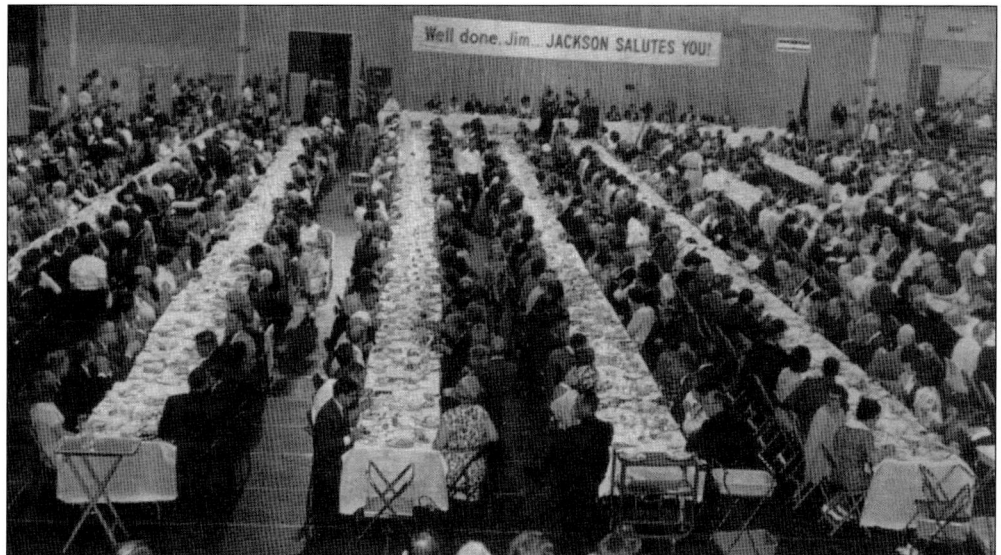

In 1965, Jackson held a celebration for local hero and NASA astronaut James McDivitt. Although McDivitt was born in Chicago, his family later moved to Jackson, and he attended and graduated from Jackson Junior College. He also received a bachelor of science in Aeronautical Engineering from the University of Michigan. McDivitt joined the US Air Force in 1951 and flew over 100 combat missions during the Korean War. He received several honorary doctorates and was given numerous special honors from the Air Force and NASA. He was the commander for *Gemini 4* and for *Apollo 9*, manager of Lunar Landing Operations, and manager of the Apollo spacecraft program, and he later went to become the manager for *Apollo 12, 13, 14, 15,* and *16*. He retired with the rank of brigadier general when he left NASA in 1972 to pursue other interests.

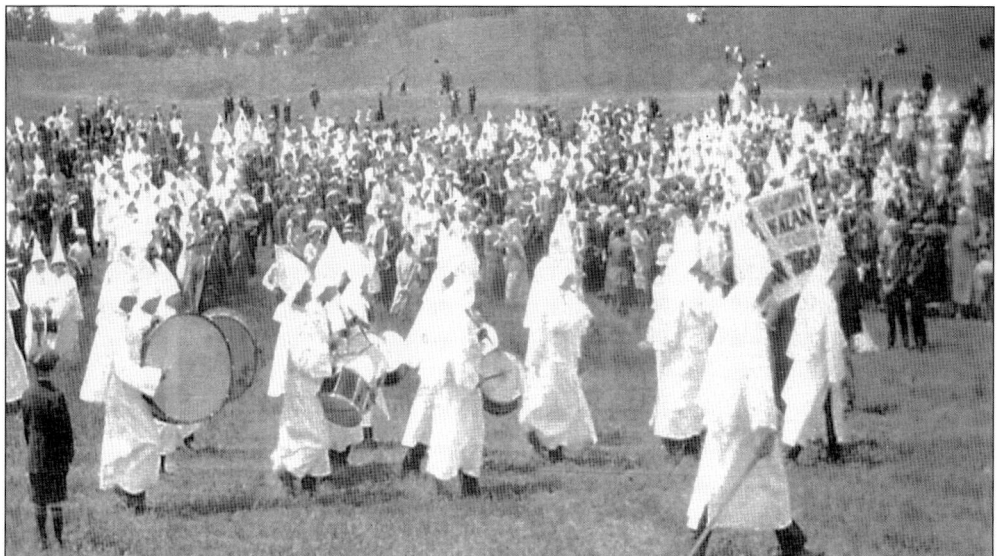

The Ku Klux Klan (KKK) gathered in a field off Seymour Street to start a parade and rally on July 4, 1924. Approximately 7,000 Klansmen from 42 counties throughout the state joined in the parade, making it one of the largest Ku Klux Klan rallies ever held in Michigan. KKK members started arriving in Jackson on July 2, 1924, setting up camps along Seymour Street and hiring buses to bring other members in from such cities as Lansing, Grand Rapids, and Kalamazoo.

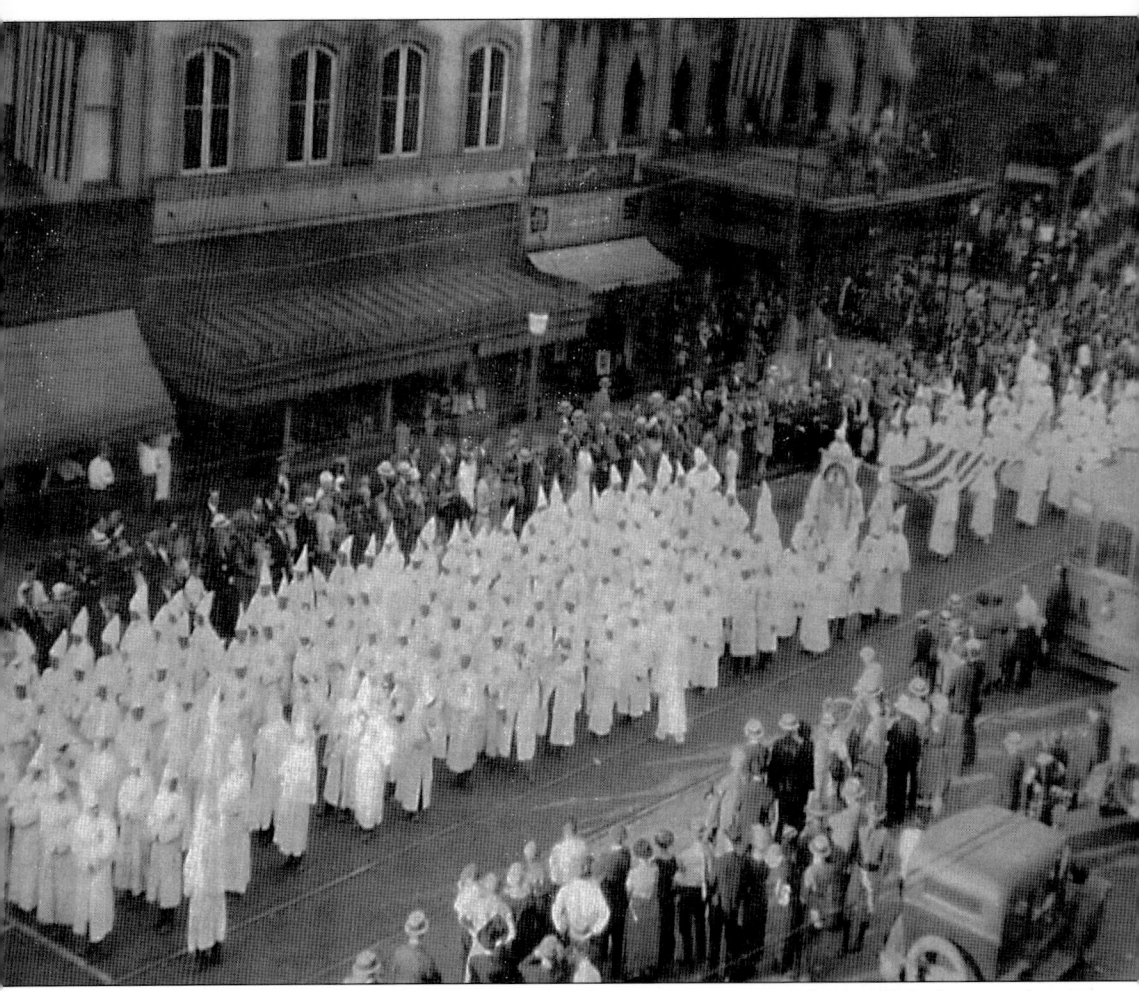

The Ku Klux Klan marched down West Michigan Avenue on July 4, 1924; the parade was approximately two miles long. The Ku Klux Klan is an anti-Catholic, anti-Jew, and anti-black organization that started sometime in the late 1800s. After the parade, the KKK held a rally that brought about 100,000 people to Jackson. At the time, the KKK was at its greatest influence, and the rally was probably held in Jackson because of its central location to major cities. Hiram Wesley Evans spoke and presented ideas that sounded like socialism but were entwined with racism and anti-Catholic ideas.

Three

CLUBS

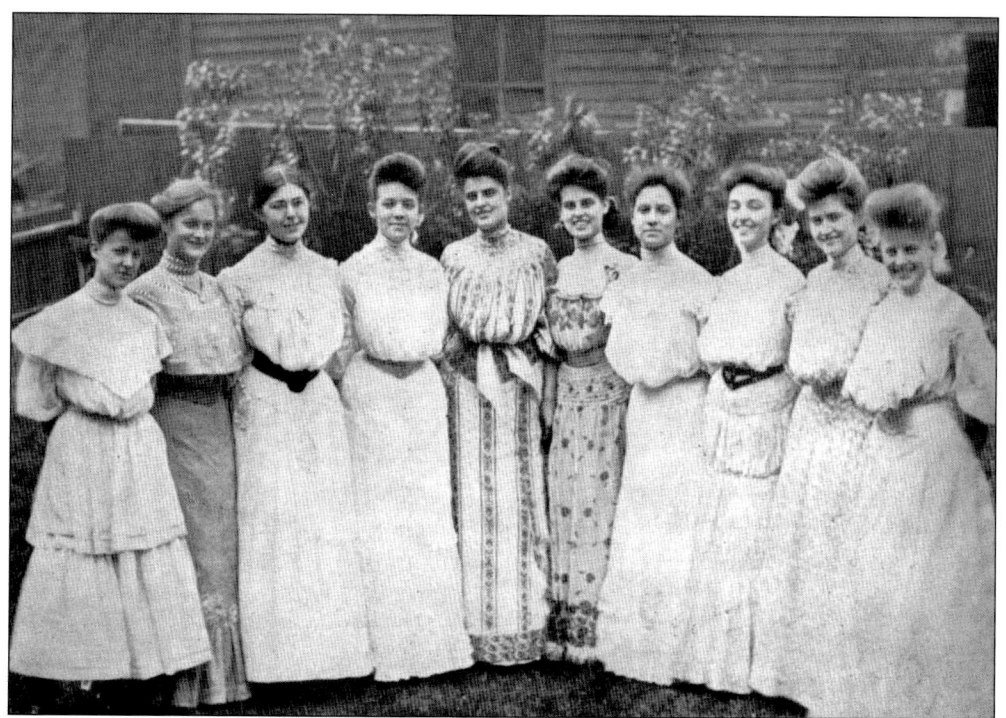

This is a photograph of Jackson High's Gamma Delta Tau organization. The Beta chapter of the Gamma Delta Tau sorority was organized in Jackson in 1898 with active members (from left to right) Margaret Lathrop, Margaret O'Dwyer, Edna Sanford, Lyna Binning, Marjorie Brown, Clara Buskirk, Hazel Hahn, Vera Harrington, Ruth Irwin, and Hazel Thorpe. (Courtesy of the Jackson Genealogical Library.)

The Alpha chapter of Delta Psi sorority was organized in 1902 at Jackson High with a membership of eight, which would later increase to twenty-six. The sorority endeavored to keep high standards among its members, especially in regards to scholarship. Active members of 1902 were Inez Town, Ella Moloney, Olga Bridgman, Florence Snyder, Janet Connor, Blanche Bullock, Hermie Hodges, Bessie Schlenker, Ella Hobart, Dorothy Bridgman, and Bertha Bucknell. This photograph is from around 1904. (Courtesy of the Jackson Genealogical Library.)

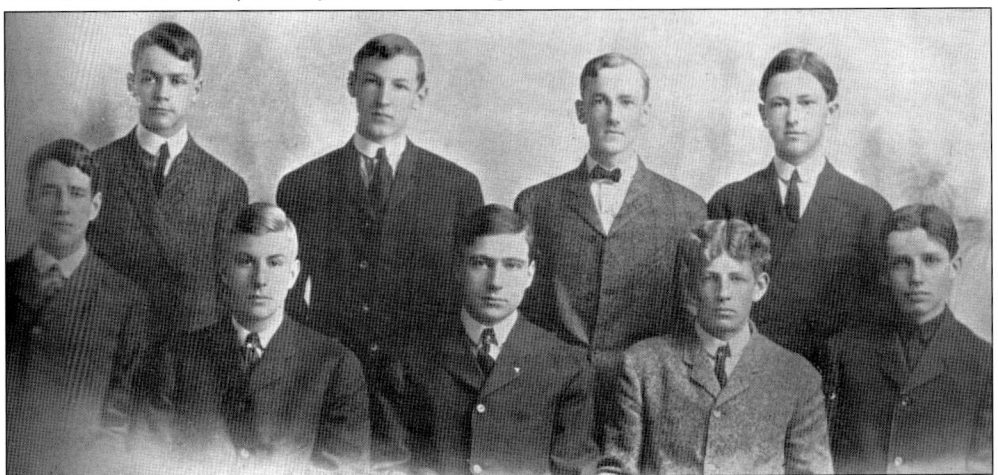

The Jackson High Kappa chapter of Mu Delta Sigma is pictured here in 1904. The fraternity's objective was to promote fellowship and goodwill among the students and to further the welfare of the high school. Active members at the time were, from left to right, Ned Irwin, Burr M. Peek, Frank R. Wallace, Fred Smith, Philip Bennett, Robert Campbell, Harold Yocum, Edwin C. Reynolds, and Ralph Allen. (Courtesy of the Jackson Genealogical Library.)

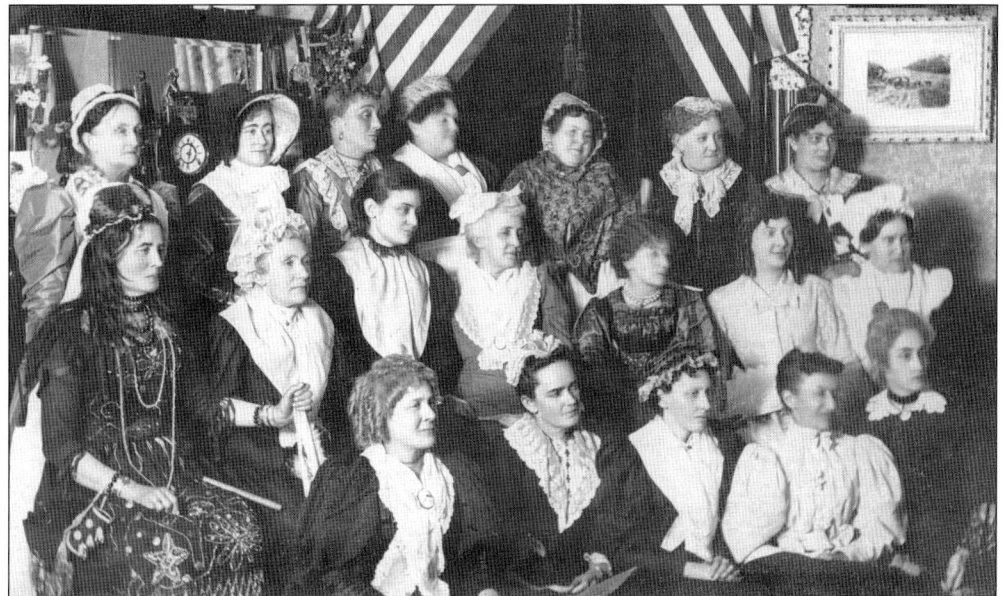

The Phoenix Club of Jackson is pictured here on April 8, 1897. Among the members were Duke, Breadley, Williston, Harleire, Paine, White, Brauch, Caretore, Crippey, Lyman, Smith, Barrett, Draper, Filtch, and Seward. The Phoenix was a social club that discussed such things as literature, drama, and social issues, and they would take turns hosting meetings at members' homes.

The inscription on the Austin Blair memorial reads, "Upon this site stood the home of Austin Blair, one of the founders of the Republican Party and Michigan's war governor from 1861 to 1865. He stayed up Lincoln's hand during the life and death struggle of the Republic." It was placed by the Sarah Treat Prudden chapter of the Daughters of the American Revolution (DAR) in September 1927. DAR members pictured here include Mrs. Barnard, Nellie Cady, Mrs. Clancy, Mrs. Clark, Mrs. Combs, Mrs. Dupress, Mrs. Foster, Marjorie Green, Mrs. Parkinson, Mrs. Parks, Mrs. Sagendorph, Mrs. Weatherwax, and Mrs. Week. (Courtesy of the Jackson District Library.)

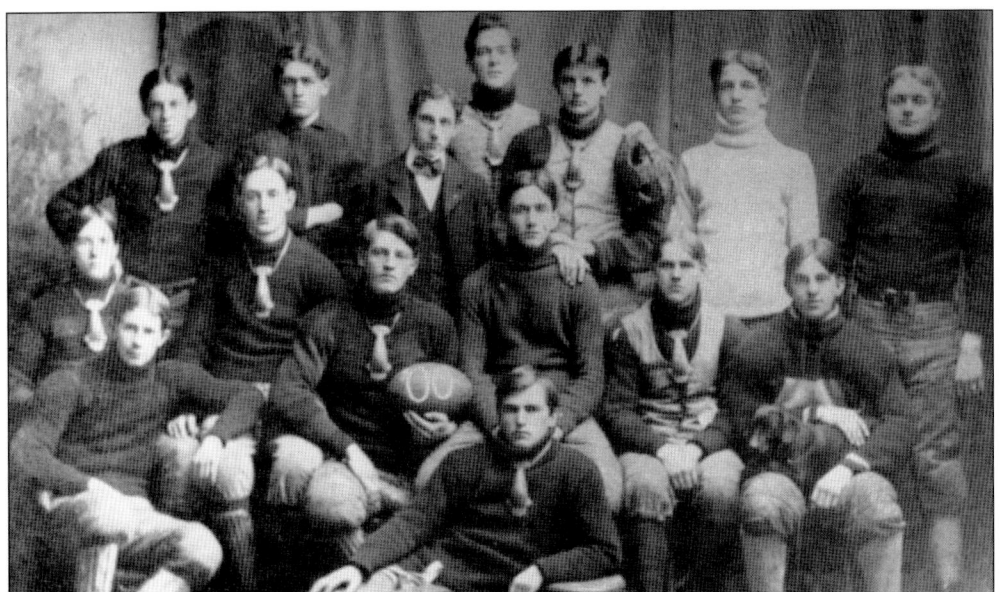

The Jackson High School football team of 1900 is pictured here. Because the school had no athletic facilities at the time, the team dressed at the YMCA downtown and walked to the fairgrounds for practices and games. In October 1900, the Jackson High School football team played a game against the Leslie High School team at the fairgrounds, and Jackson won 40-0.

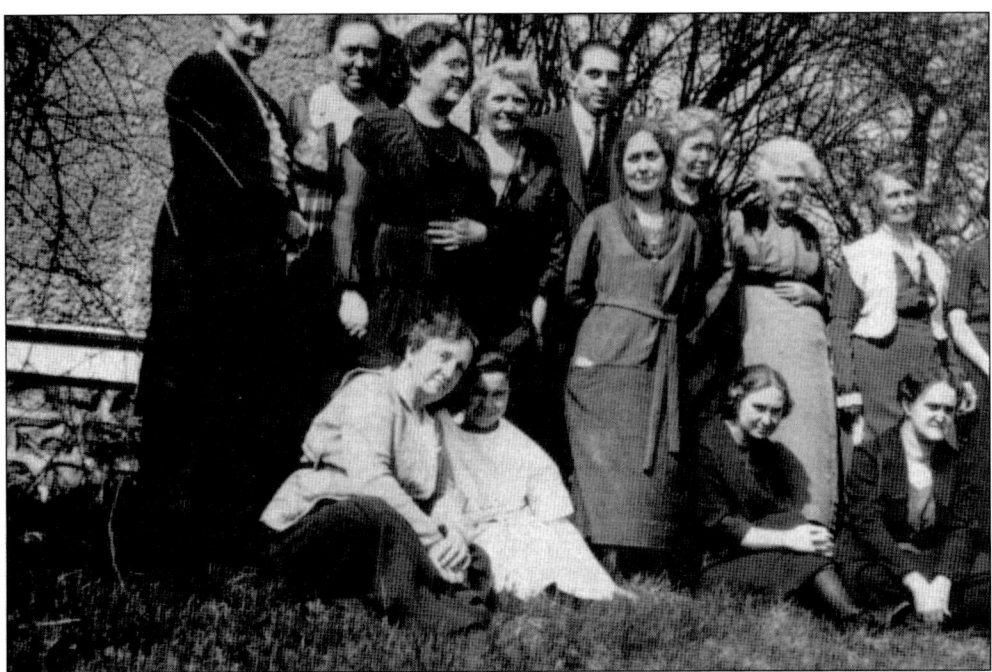

This April 13, 1922, image captures the Thimble Club, whose members included Donald Maluright, Mrs. Blaucy, Mrs. Bryant, Mrs. Milleken, Helen Resserluig, Ruth B., and Ira. The Thimble Club was a social sewing club that would meet in various community members' homes. Historically, such clubs would sew quilts to donate to those in need.

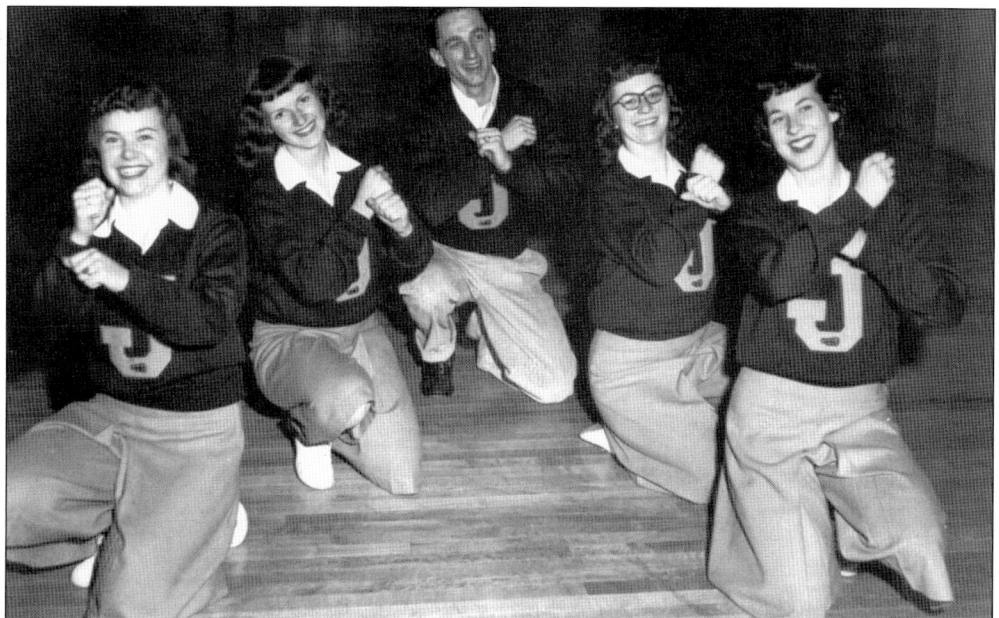

These Jackson Junior College cheerleaders (from left to right)—Joanna Pregitzer, Raechel Claire, John Coates, Mary Lou Van Gieson, and Donna Tyler—were photographed around 1945 or 1946. Although women were joining cheerleading teams in the 1920s, it was not until the 1940s, when so many college-aged men went off to fight in World War II, that they joined in large numbers. (Courtesy of Jackson College.)

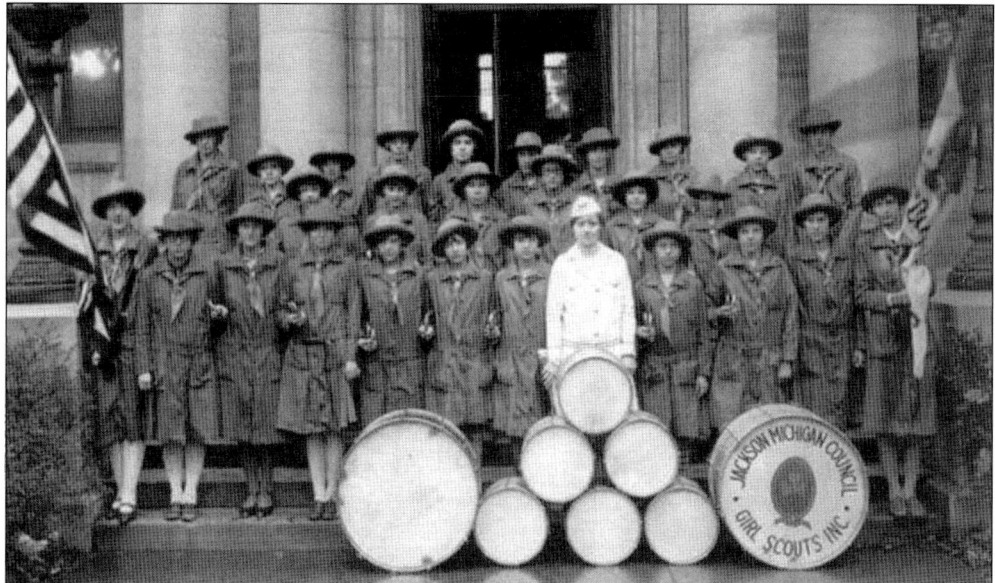

This Girl Scout band is pictured around 1940 standing in the rain in front of the Carnegie Library. The Girl Scouts of America was founded in 1912 by Juliette Gordon Low, with the help of Sir Robert Baden-Powell (founder of the Scouting movement). The first American Girl Scout troop was founded in Savannah, Georgia, home of Juliette Low. The organization's goal was to inspire girls to succeed and help teach values by awarding badges as incentives. (Courtesy of the Jackson District Library.)

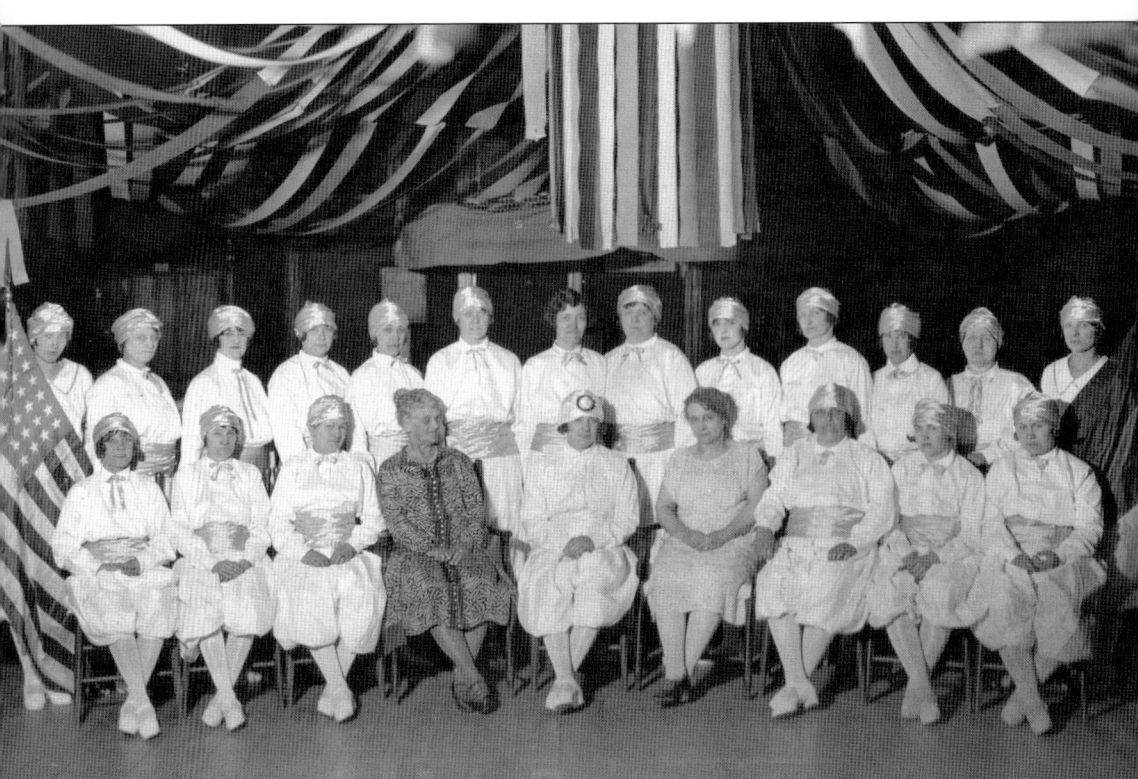

This is a 1931 photograph of the Order of the Eastern Star, an organization for women aged 18 and older who have relationships with Freemasons. Originally, a woman had to be the daughter, widow, wife, sister, or mother of a Master Freemason to become a member. Despite modern-day conspiracy theories about the Masons, the Order of the Eastern Star was a charitable and social club. The Jackson Order of the Eastern Star was founded in 1907.

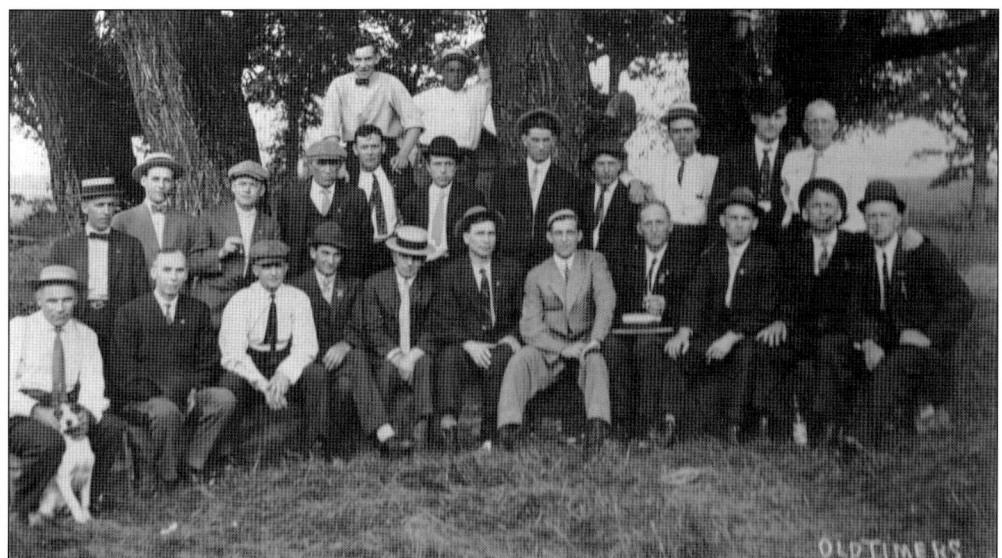

The Old Timers Club, pictured on August 10, 1912, was a group of long-standing Hayes Wheel Company workers who met to plan fun and charitable activities for their community, including baseball games, picnics, and races, some with a humorous touch. In 1913, the club had grown to over 50 persons and talked of building a larger place for meetings.

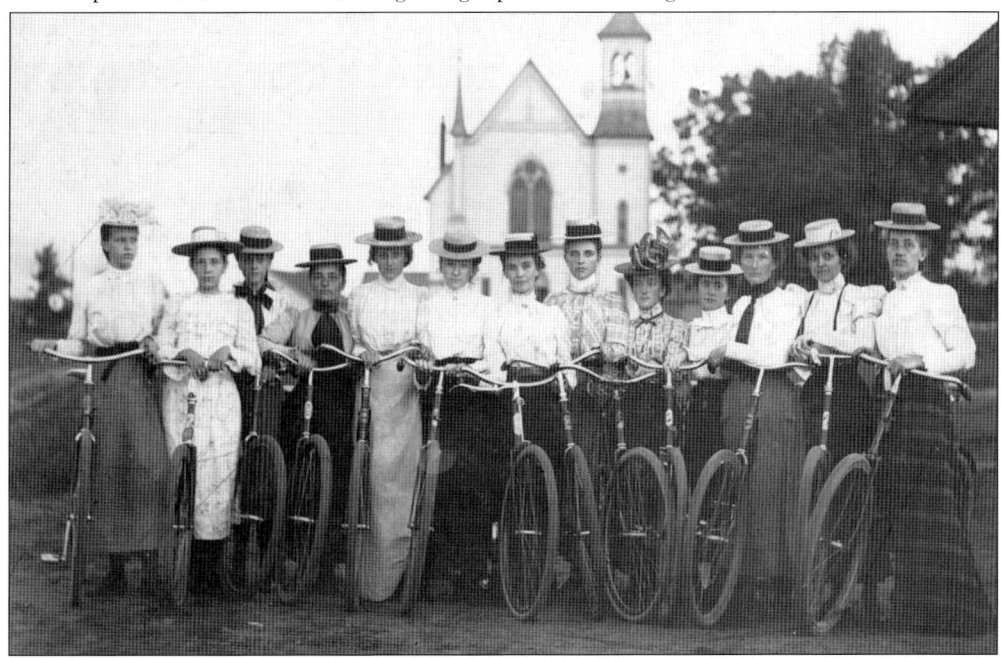

In the 1880s and 1890s, growing middle-class participation in cycling led to the formation of hundreds of bicycle clubs across the United States. Bicycling became accessible to the population with the mass-produced, chain-driven safety bicycle, and a huge boom in bicycle sales occurred. Pictured here on August 14, 1900, is the Hanover women's bicycle club. Members are, from left to right, Maud Dickinson, Winifred Snow Elmore, Edwina Levy, Mrs. Towler, Mary Schock Herring, Mrs. Hammord, Lucy Drake, Mrs. Duffs, Ferne Adams, Linnie Rogers, Zoe Russell Rogers, Mrs. Barnes, and Mrs. Phelps Hall. (Courtesy of the Hanover Historical Society.)

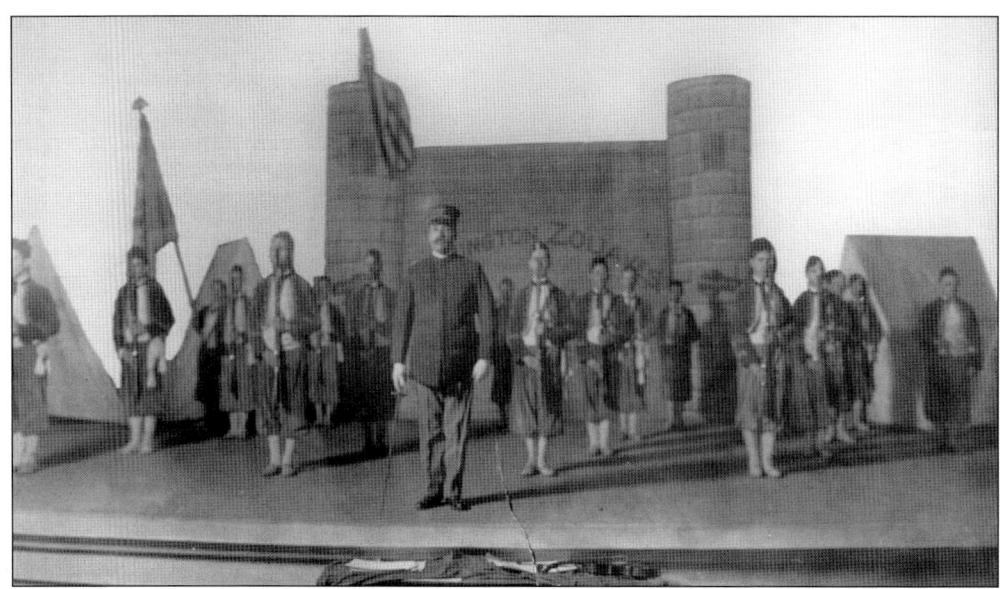

The Jackson Zouaves were world renowned, performing their drill routine with rifles all over the globe. They are famous for their part in a movie called *The Court Jester* starring Danny Kaye and Angela Lansbury. In the fall of 1903, the Jackson Zouaves were asked to appear with the Buffalo Bill Wild West show. As the main feature of the show, they performed in London, Rome, and other cities in Europe. Zouave was originally a name given to a group of French soldiers who served between 1831 and 1962 and were known for their unique and colorful uniforms, which included a short open jacket, baggy pants, a belt, and a fez hat.

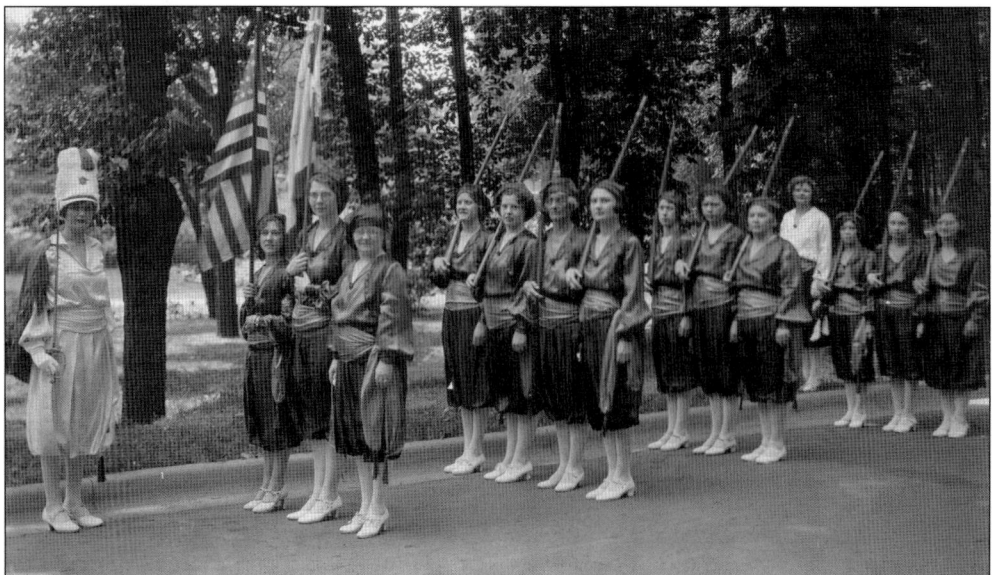

The Women's Zouaves drill team performed the same steps as the all-male drill team and wore the same type of uniforms. Jackson's first Zouaves group was made up of Devlin Business College students and was organized around 1898 by college president George M. Devlin after his return from fighting in the Civil War. Later, the Zouaves were led by his son Harry C. Devlin, who was an instructor in sports and athletics at his father's school. Capt. George M. Devlin died May 6, 1927, at the age of 57.

Four

WORK AND LIFE

Daily Citizen staff members stand in front of their building around 1900. James O'Donnell owned the *Daily Citizen* newspaper from the 1860s to 1905, when he sold it to John George Jr. of Jackson and Ralph H. Booth of Detroit. In 1925, Booth Publishing Company bought out the *Jackson Patriot* and created the *Jackson Citizen Patriot*.

Lake Farmers Telephone Company was established in Grass Lake by Nelman Wing and John Fuller in 1900; the company's first customer was the editor of the *Grass Lake News*. By 1957, the telephone was no longer a luxury item, and the Farmers Telephone Company had more than 700 customers. In 1907, the name was changed to the Home Telephone Company, and in 1948, it became the Grass Lake Telephone Company. (Courtesy of Dan Cherry.)

Parma's first school was established in 1856 and was built by Col. John Anderson. The two-story structure had two rooms on the first floor used for the school, and a second-floor room that served as a courtroom. On November 12, 1886, bonds were issued in the amount of $12,000 to erect a new brick school on a site in Sandstone Township. The first graduating class had seven members. This photograph of Parma High School dates to 1920.

The history of Dibble School (pictured here in 1901) dates back to the 1800s. The original log schoolhouse was replaced in 1868 with a stone building, which was replaced by a wood structure in 1885. A new school was constructed in the 1950s. In 1960, an addition was added that included a library. In 1967, the wood structure was donated to the Ella Sharp Museum. It currently is used in the museum's educational living-history program, Pioneer Living, throughout the school year.

In the late 19th century, not every child in Jackson had the opportunity to attend school; many had to work to help support their families. In 1883, the Michigan legislature passed a law decreeing that all children between the ages of eight and fourteen must attend school at least four months of the year. One-room schoolhouses sprouted up in rural areas to teach the local children reading, hygiene, spelling, arithmetic, penmanship, grammar, and geography. Many of the teachers of the one-room schoolhouses might not have been much older than the children they were teaching. It was not uncommon to have a 16-year-old teaching a small classroom. Teaching was one profession that welcomed women. In this c. 1914 image, children sit beside the Concord Elementary and High School on Maple Street south of Homer Street. The school burned in 1943, and classes were moved to Concord's opera house until a new facility was built in 1953. (Courtesy of the Hubbard Memorial Museum Foundation.)

Napoleon Grammar and High School is pictured here in 1909. Its teachers were Clarice Nowlin and Adell Lazell. Napoleon School was built in 1897 and once had classes for all grade levels. It was torn down in 1980. (Courtesy of Mickey Hardcastle.)

Primary School Brooklyn was originally constructed as a church and later became a school for the younger grades. These children are seen at recess around 1904. (Courtesy of David Raymond.)

Brooklyn High School was built in 1869 and was updated and remodeled in 1924. It had four large rooms; the two rooms upstairs held classes for ninth through twelfth grade, while the two large rooms downstairs held classes for third through eighth grade. The school was demolished in 1996. (Courtesy of David Raymond.)

The congregation of Norvell Community Baptist Church is pictured on September 4, 1911. The church was dedicated Wednesday, April 10, 1871, and the sermon was preached by Rev. L.D. Palmer. After the sermon, the Reverend F.H. Davis gave a short history of the church and explained the building expenses. The total cost of the furnishings, bell, and grading was $5,013. An addition was built onto the church in 1963. (Courtesy of Mickey Hardcastle.)

The use of steam engines required large boilers, which were made by the Keeley & Crowley Jackson City Boiler Works (Later Crowley Boiler Works), located at 431–433 North Jackson Street. They manufactured boilers and sheet-iron goods. The proprietors were James J. Keeley of 117 Blackman Street and John Crowley of 112 North Waterloo Avenue.

The Dawn Donut Company provided baked goods to Jackson's families in the early 20th century. The bakery was first located at 112 East Michigan; by 1920, its products had become so popular that a company was formed to sell patented baking mixes. The company moved to 330 Otsego Avenue in 1920, and the bakery was closed around 1930 as the company began to focus exclusively on making baking mixes.

In this c. 1899 view of the Jackson Corset Company, long tables are arranged like an assembly line, with the employees making almost 500 corsets every day. A corset was a confining undergarment worn by women to constrict their waists for the fashion of the time. It was made with a laced or hooked undergarment reinforced with steel or whalebone. It was very common for women to faint because their corsets were too tight. Jackson Corset Company was founded in 1884 at 233 West Main Street and became the largest manufacturer of corsets and other waist garments in America. It later moved to 209–215 West Cortland Street and employed almost 300 people by 1895.

Employees install wiring on Sparton C-3 flight trainers around 1941. These wooden cockpit replicas were used by the US military to train pilots. Inside were simulated aircraft instruments, and a series of motors and tracking devices replicated the motions of flight while recording the student's performance on a piece of paper for later review.

Seven unidentified children stand beside a car parked in front of the Hanover Library for a photograph around 1910. The library had previously been the fire department, with the jail upstairs. (Courtesy of the Hanover Historical Society.)

The first fire station was built in 1843 on East Main Street at the southwest corner of Main and Park and stood on the small triangle park owned by the railroad in front of the depot. This station was later moved by the railroad to the southwest corner of Elizabeth and Van Dorn Streets. Firehouse No. 1 was built in 1883 on West Cortland between Jackson and Blackman on the north side of the street. Church bells would ring to alert firemen of a blaze. Fires usually had a good start because it took time to get the wagons and horses prepared to race to the site. Different fire departments throughout the city would have races to see how fast they could prepare the horses and wagons and get to a set spot. The first fire chief of Jackson was Peter DeMill, who served from 1843 to 1857.

The fire department is pictured around 1909 at Firehouse No. 1 on Cortland between Jackson and Blackman. Here, automotive fire engines have replaced the horse and wagon. But the fire trucks were new, and there were still four fire-horse units in the station. Peter B. Loomis served as fire chief from 1857 to 1858.

Jackson County policemen pictured here are, from left to right, Frank Watson, ? Crocomb, Ben Chase, Tom Reardon, unidentified, ? Bryden, Tom Parker, Ed Able, ? Booth, John Hudson (chief of police), Bert Fall, and ? Holsaful. They were attending the funeral of one of their fellow officers, Charles Bernard Maloney, in September 1917.

Fire chief Benjamin King is pictured in his horse and buggy as he looks at the first motorized police patrol wagon in front of the police station in Jackson. Benjamin F. King was chosen as commander of the firefighting force in December 1897 and was head of the department for 30 years. (Courtesy of the Jackson District Library.)

Michigan was a large logging state, and Jackson County had many valuable hardwood trees. Lumber was cut along the Grand River, and because the logs were far too big and heavy to take from the woods by dragging, the loggers made ice-covered roads where the logs could be pulled on sleds. The timber would be shipped on the Michigan Central Railroad. The lumberjacks lived in bunk-style cabins during the early years of the lumber industry near the Grand River. The camp consisted of bunkhouses, a cook shanty, a barn, a blacksmith shop, a camp office, and a store. It was less difficult to cut trees in winter because logs could be easily transported to riverbanks by bobsled or by railroad. In spring, when the ice melted, logs were floated down the river to sawmills. Many men made huge fortunes from the logging industry, and other results included the growth of cities around the mills and the rapid spread of farming because of the already cleared land.

The A.J. Austin family of Norvell, Michigan, poses for a photograph in front of their car and farm just west of Napoleon. A.J. Austin, a respected farmer, was elected Norvell supervisor by 22 votes on April 3, 1895. He was also a founding member of the Jackson County School Officers Association, whose goal was to increase the efficiency of Jackson County schools. (Courtesy of Mickey Hardcastle.)

The men of the Rice Seed Farm, pictured here in 1918, planted and raised flowers, radishes, carrots, cucumbers, squash, rutabagas, potatoes, tomatoes, peppers, watermelons, muskmelons, parsnips, and turnips. They were all Grass Lake area men, such as Eric Plummer, Bill McCurdy and sons Olin and Harlan, Elmer Lantis, McCalla, Al Gardner, Ed Seger, Frank Abbott, Albert Shinaberry, Albert Wollpert, George Starr, and Sherman Bowman. The farm ended in 1924. (Courtesy of the Grass Lake Historical Society.)

The John Bunker family's farm was built in 1836 on Willis Road. Pictured here are Frances Bunker Moon (born 1861); her husband, Thomas; their two children, Elva and Rocne; Frances's brother George Bunker; and a hired man. Frances and George were grandchildren of John Bunker. (Courtesy of the Grass Lake Historical Society.)

"Dutch" Wolfe, who came to Grass Lake in 1909, is pictured holding a foal in this postcard dated 1913 and titled "Life on Village Farm." In 1971, Wolfe was interviewed for *A Doorway to the Past: A Selective History of the Grass Lake Area*. He talked about the people and places that were once part of the Grass Lake area. (Courtesy of the Grass Lake Historical Society.)

The young Grass Lake women posing for this picture are Cleo Clark, Grace Mohr, Marie Bolton, Glady Fisk, Mabel Berger, Nellie Cairns, Bertha Corwin, Evelyn DuBois, Mattie Craft, and Bertha Rohrer. (Courtesy of the Grass Lake Historical Society.)

These cows are being herded by farmer A.J. Austen to be loaded on the freight train in a stock car at Norvell, Michigan. A stock car is a type of rolling stock used for carrying livestock to market. A traditional stock car resembles a boxcar with louvered sides for the purpose of providing ventilation; stock cars can be single-level for large animals, such as cattle or horses, or they can have two or three levels for smaller animals, such as sheep, pigs, and poultry. (Courtesy of Mickey Hardcastle.)

Here, ice is being loaded into refrigerated freight cars in Norvell. The ice was first harvested by workers who scraped off the snow and scored the ice before sawing it into large blocks. Teams of horses would drag the ice, and it would be loaded onto wagons and brought to the icehouse near the station, where conveyor belts moved it into position to be loaded onto the freight trains. To be preserved for summer, the ice would be stored in an icehouse and covered with sawdust. (Courtesy of Mickey Hardcastle.)

In this image, farmers are selling poultry to William E. Clark in Brooklyn. The poultry will be shipped out later on the freight train. Moving livestock by railroad was common from the 1860s to the 1960s, and chickens would be placed in a freight train that had wire mesh cages and was heated in the winter. (Courtesy of Mickey Hardcastle.)

Fred Boobyer, Roy Reynolds, Harry Horton, and Royal King are pictured pitching hay in 1910. In the early 1900s, hay was not baled but was hand tossed into the loft of a barn for the horses or cattle. Royal King was known for his sleigh-ride parties and for breeding successful racehorses. (Courtesy of Parma Township Office.)

Horse-drawn streetcars on rails, like this one pictured in 1886, were the forerunners to the electrified trolley cars. An electric-powered interurban was later installed. The interurban cars transported passengers by rail from one city to another or from one dance hall to the next.

Earl Motors Incorporated in Jackson made cars from 1921 to 1923. Benjamin Briscoe of Briscoe Motors appointed Clarence Earl president of his company in 1921, and Earl was given the company the same year after Briscoe had no more use for it. Earl assumed many problems with the company, including $1.5 million in debt. He resigned in November 1922 over differences with his board members, many of whom were his company's bankers.

In this photograph, a Briscoe employee is performing a tolerance test on a camshaft. Tolerance tests indicated how close the camshaft was to the desired standard size. Briscoe Motor Corporation adopted mass production and moving assembly line techniques, which led them to produce 50,000 cars within seven years.

The assembly line was new in manufacturing. Briscoe Motors invested heavily in laborsaving machinery, and its assembly line, which was over 500 feet long, used a chain drive to pull the frame of the car being assembled.

A 1923 Earl automobile is seen parked in front of a Jackson home. The car manufacturer was keen to point out that the vehicles were so easy to operate that "even a woman could drive it."

Interurban employees are pictured here installing a spring switch for a turnout siding. Jackson was a center of interurban transportation in south central Michigan. Interurban offered fast and frequent transportation north, east, and west of the city to Battle Creek, Ann Arbor, Detroit, and Lansing. (Courtesy of the Jackson District Library.)

This is the Barber Shop and Bath Room of Edward Stoeckle. At one time barbers were also expected to perform medical procedures, and the traditional barber pole was a sign that medical procedures were performed in that shop: red represented blood and white represented bandages. Eventually, the barber poles began to represent a barbershop that cut hair and gave shaves. (Courtesy of the Jackson District Library.)

Built by Edward Copen in 1856, this was the first gas works in Jackson. This building was enlarged at various times, and housed various gas companies. George F. Sherwood became superintendent of the Jackson Gas Works in 1876. Later, the structure was used as a horse stable called the Emmons Stables. In this picture, taken around 1930, it was being used as a storage garage for automobiles. It was located on Pearl Street, east of Mechanic Street. (Courtesy of the Jackson District Library.)

The old post office was located at Washington and Mechanic Streets. Construction started in 1892 but was not completed until 1894. After being replaced by a new post office, this building was used by the Federal Relief Organization for a few years and was later sold to a private enterprise. (Courtesy of the Jackson District Library.)

S. Frank Longobardi's store, located at 235 Main Street, is seen here in 1886. The family lived on the second story of the building. Pictured are, from left to right, John Longobardi, S. Frank Longobardi, Fred Russ, Lewis Russo (who sold fresh fruit, vegetables, and ice cream) and unidentified. Longobardi was born December 25, 1842, in the Positano in Salerno, Italy. He immigrated to Jackson in 1875. (Courtesy of the Jackson District Library.)

Hague Park employees pose together in 1908. This dedicated staff operated and maintained the vaudeville theater, dance hall, bowling alley, shooting gallery, rental boats, carousel, roller rink, balloon ascensions, ballgames, concessions, roller coasters, and a steamboat that offered rides around the lake, in addition to other rides. In 1923, a fire destroyed much of the park. It closed entirely during the Great Depression.

The first gasoline-powered delivery truck for Adler Brewing Company is pictured on the old East Pearl Street Bridge. Note the wooden planks. Adler Brewing boasted that they made the purest, healthiest beer and would reward $5,000 to anyone who could prove otherwise. (Courtesy of the Jackson District Library.)

Stephen Kenk's lodging and saloon was located at 318 South Park Avenue in 1880. Jackson had over 70 saloons during this time, most of which were located near the city's industrial center on the east end of Main Street. At this time, a liquor license was $500, so it was common to have multiple partners owning a saloon. Stephen Kenk was an immigrant from Germany who arrived in Jackson in 1882.

This is an early photograph of the Eberle Brewing Company's employees. The man sitting second from the left with the dog between his legs is Carl Eberle. Eberle Brewing employed its own cooper (a person who makes or repairs vats and barrels) to make the kegs for the company's beer.

Eberle Brewing Company distributed its products to saloons throughout Jackson by horse-drawn wagons. In this photograph, the horses and employees stand just outside the company building in 1908. The Eberle Brewing Company, located on Water Street, made several different kinds of beer; during Prohibition, they produced different flavors of pop.

The Eberle Brewing Company was called the Jackson Brewing and Malting Company until it changed its name in 1898. Starting in 1896, the company developed soft-drink flavors, and soft drinks were its only business during Prohibition, from 1919 to 1933. Brewing resumed after Prohibition until 1941, when it became the Eberle Bottling Company. The company was sold outside the Eberle family in 1964. This image dates to around 1900. (Courtesy of the Jackson District Library.)

The interurban, a type of electric car that transported passengers between cities, was popular from 1900 to 1925. The cars also allowed fast and easy access to cities for people who lived in the suburban or rural areas. The first passenger interurbans were horse-drawn carts on rails that later became electrified, and the track was extended outside of town to connect the rural areas. This image of the East Michigan interurban is from 1936.

Interurban cars offered fast, frequent, and comfortable service from Jackson to surrounding lakes, dance halls, and pavilions. The interurban also traveled to Ann Arbor, Detroit, Battle Creek, and Kalamazoo with an extensive network of lines across southern Michigan. These men are posing before boarding an interurban car.

Thorpe Carriage Company, a manufacturer of fine carriages and buggies, is pictured at the corner of Clinton and Jackson Streets in 1895. Dyer P. Thorpe, president, resided at 609 South Jackson. The company, which employed 200 workers, made 6,000 horse-drawn vehicles every year and distributed them all throughout the United States.

This is the workroom of William Henry Pittelco's tailor shop, located at 148 West Main Street in Jackson. Tailor-made clothing was the norm in the 19th century. A tailor cuts fabric and creates garments according to a pattern specific to a customer's body. William Pittelco was born in Jackson on May 6, 1871, and died in September 1969. (Courtesy of the Jackson District Library.)

Coal was first discovered in Michigan around 1835 as pioneers built a gristmill west of Jackson. In 1837, Michigan's first geologist, Douglass Houghton, reported that the bed and bank of the Grand River at Jacksonburgh (Jackson) held a bed of shale mixed with a very thin layer of coal. Much of the coal existed in outcrops, which made excavation easy. Trumble Mining is pictured here in 1890.

Leonard H. Field was a cousin to Chicago department store icon Marshall Field. He eventually became a partner in a store called Stone, Field and Wakefield. In 1869, he bought out his partners and moved to Jackson, which had 10,000 residents and was the center for six railroads. In 1891, he incorporated and renamed the store, located at 201 West Michigan Avenue, the L.H. Field Company. The store was extended to Cortland Street and included the new Rose Room restaurant in early 1955. The building was demolished in September 1991. (Courtesy of the Jackson District Library.)

In 1915, William Sparks appealed to his sons Clifford (Cliff) and Harry to travel to the West Coast along the Lincoln and National Highways. Sparks's sons erected signs along the highways that promoted, "Safety First, Sound Sparton." The signs were installed near curves, hills, and blind spots. Here, Cliff (left) and Harry stand next to a truck bearing the Sparton slogan. The brothers made their journey safely and put up hundreds of signs across the country.

In 1879, telephone service came to Jackson. This Michigan Bell Telephone installation-and-repair crew pose in front of the telephone building, which was located on Cortland, around 1885. The Bell Telephone Company was officially incorporated in Boston on July 9, 1877; by October of that year, the Michigan Telephone & Telegraph Construction Company had been granted a license to operate phone lines in the Detroit area. (Courtesy of the Jackson District Library.)

As demonstrated in this photograph from around 1890, telephone crews helped to install poles in Jackson for electricity and telephone service. The telephone caused two major social changes: it made it acceptable for women to work the telephone lines and switchboards as operators, and it became the most common form of communication. The first phones were rustic, with lines linked to each other by wires hung about the tops of buildings. In addition to poor sound quality, the early Bell telephones had only one transmitter/receiver, which required mouth-to-ear shifting.

William D. Chapple and son Percy collaborated in organizing the first National Bank in Concord, under National Bank Charter, in 1884. In 1886, the bank was reorganized under state charter as the Famers State Bank. William Chapple was president, and Percy was the cashier. Upon his father's death in 1906, Percy became president. The Farmers State Bank of Concord, Michigan, is seen here around 1899. (Courtesy of the Hubbard Memorial Museum Foundation.)

Pictured in Concord in 1915, Marion Hubbard and Frank Hubbard Hungerford are standing in front of sheep that are being herded to the stockyard to later be shipped as freight. Prior to the automobile, the railroad was the most common carrier of natural resources. (Courtesy of the Hubbard Memorial Museum Foundation.)

Hanover Hotel was located on Main Street in Hanover. Sol Middleton, a saloon owner from Eaton Rapids, leased the hotel on June 24, 1884, and gave a formal opening in the evening. The stables were located in the back. Hanover Hotel later became Tesch's hardware store and eventually burned down. (Courtesy of the Hanover Historical Society.)

The Wiggins Furniture & Undertaking carriage, seen here around 1880, was made by the Michigan Buggy Company in Kalamazoo; however, there was a store that sold carriages and cutters (light sleighs) on the east side of Main Street in Concord. Michigan Buggy's catalog would include buggies, carts, wagons, and cutters. Wiggins Furniture & Undertaking, located in Concord, prepared the dead for burial and arranged and managed the funeral. They also made quality coffins and furniture. (Courtesy of the Hubbard Memorial Museum Foundation.)

With a growing population, water and waste management became problems. The City Water Works Station was built in 1885 to provide Jackson residents with cleaner water and sewage removal. The building, photographed in 1878, had French Second Empire mansard roofs that were topped with iron cresting above the Italianate arched windows. (Courtesy of the Jackson District Library.)

68

Five
FUN AND AMUSEMENT

The children in this c. 1910 image are enjoying the day in the Carnegie Library at 244 West Michigan Avenue in Jackson. In May 1902, architects Ferry & Class of Milwaukee, Wisconsin, were hired to draw up the plan for the new library. Bids were opened in June 1903, and Charles A. Hoving was awarded a $65,000 contract for the construction of the new building. Work began in the fall of 1903. Although the contract called for completion by July 1, 1904, the library did not open until August 1906. It has been a community meeting center ever since. (Courtesy of the Jackson District Library.)

Badger baiting/fighting was a blood sport—much like cock fighting or dog fighting—in which badgers were used as bait for a dog. A baiting session typically resulted in the death of the badger and possibly serious injuries to the dog. In order to maximize the badger's ability to defend itself and to test the dog, a badger den was built, and the badger placed in it, before the dog was released. A person with a stopwatch would keep the time to see how fast the dog could catch the badger. Once the dog had the badger in his mouth, it would be commanded to release the animal. This process would be repeated, and the canine with the fastest time would win the fight. This image of a badger fight is from around 1900. (Courtesy of Mickey Hardcastle.)

Parma hunters (from left to right) ? McKenzie, Mark Hawes, D. Bullen, Royal King, Morris Borner, Jay King, and ? Hartung display their prized buck in 1910. This group, which varied in size each year, went up to the upper peninsula for deer hunting. (Courtesy of Parma Township office.)

Sulky racing (harness racing), as seen in this photograph from July 27, 1907, was a popular way to pass the time. In North America, trotting races had become a popular rural pastime by the end of the 18th century. In the early 19th century, the first harness racing tracks where established, and trotting races were incorporated in the list of attractions at any county fair. A sulky cart is a two-wheeled, lightweight cart having only one seat. Racing in Brooklyn took place where the current Elias Big Boy Restaurant now stands. (Courtesy of Mickey Hardcastle.)

The pavilion at Ocean Beach was situated at the lower, eastern end of Clark Lake in Brooklyn. It was built and managed by Leo Steinem in the late 1920s and was a popular summer retreat until 1944, when it was torn down. Half the floor was open to the elements and could be partitioned off in case of inclement weather. Many famous bands performed here, including those led by Guy Lombardo, Wayne King, Vincent Lopez, Kay Kyser, Sammy Kay, and Duke Ellington. (Courtesy of Mickey Hardcastle.)

Located on the east side of Brooklyn, Vineyard Lake has also been a place to relax and have fun for visitors. The lake itself takes up 505 acres and boasts an 8.5-acre park beside it. Visitors can enjoy swimming, boating, picnicking, and fishing. (Courtesy of Mickey Hardcastle.)

Farmers competed against the Village of Brooklyn administrators in this baseball game, which was followed by a picnic. Baseball clubs were popular in cities and villages and teams would play against other local clubs. (Courtesy of Mickey Hardcastle.)

Willow Grove Hotel (originally called Pangburn House) was one reason to visit Wamplers Lake in the Brooklyn area. Wamplers Lake was known for its wonderful fishing, bathing, and boating, and for being a generally cool place away from the city. At the time of this July 16, 1897 image, Willow Grove Hotel had no vacancy available as city people arrived to avoid the heat wave of that year. This hotel was once owned by Eula Hardcastle. (Courtesy of Mickey Hardcastle.)

This Hillside Farm prizewinning trotter, Jennie Merriman, was born in May 1891. Ella and John Sharp decided to focus on raising trotting horses instead of general farming, and several of their horses were very successful in the racing circuit. John Sharp was once quoted at the Jackson County Horse Breeders Association as saying that "Jackson is the Lexington of the north." Harness races feature what is known as a standardbred horse. The term *standardbred* originated with the many standard requirements that made a harness racehorse great. A standard track was one mile, and a standard time was two and a half minutes maximum. Harness racing was popular in Jackson County for many years until the closing of the Jackson Harness Raceway in December 2008.

Susie, a Kodiak bear at Ella Sharp Park Zoo, entertains spectators by climbing her tree in this 1931 photograph. When the zoo was started at Ella Sharp Park in 1927, its 16 animals included a black bear, a pair of buffalo, one coyote, four monkeys, two porcupines, two woodchucks, three great horned owls, and one red-tailed hawk. A baby elephant named Tribby was a later addition. Hilda MacDonald, wife of Alfred J. MacDonald, advocated a zoo in the park to provide educational and recreational features to the children of Jackson County. Hilda MacDonald was a member of the state board. She was involved in much local charity work.

In 1890, farmer Edrick Hague developed a picturesque spot near a lake on land that he owned. This beautiful site caught the attention of three wealthy developers from Pittsburgh, including a man named Albert O'Dell. They leased 110 acres from Hague and eventually bought the property and started the development of an amusement park. They also added a vaudeville theater in 1907, and then a dance hall, a bowling alley, a shooting gallery, rental boats, a carousel, a roller rink, balloon ascensions, ballgames, concessions, and a steamboat that offered rides around the lake. The rollercoaster pictured here was nicknamed the "Rabbit."

Hague Park in Vandercook Lake was a popular destination from 1910 to the 1930s. The park could host up to 30,000 people on a popular holiday such as the Fourth of July. An electric streetcar ran from the depot in Jackson up to the park. In 1926, Albert O'Dell sold the property to Eugene Bethel and his father, Edmund Bethel. The Bethels enlarged the roller coaster and did some other improvements. The park's closure in 1938 was due to both the Depression and the Bethels' health problems. The waterslide at Hague Park is pictured here around 1920.

A large party of people enjoy a picnic in the 40-acre park at Michigan Center Lake. Michigan Center Lake is only four miles east of Jackson, which was a short drive or trip on the interurban. There were dozens of nice boats and clubhouses along the banks, and an excursion steamer capable of carrying 100 passengers made a three-mile trip up and down the lake every hour during the day and evening.

On July 4, 1905, the Jackson County Fair featured staged head-on collisions between obsolete trains. The trains collided at relatively low speed, but this type of staged fun was later discontinued because of possible injuries to observers.

In 1941, the General Products Company received orders to build parts for aerial demolition bombs, and by December, more then half of the entire plant facilities were dedicated to the war effort. This General Products picnic took place on August 20, 1943.

By August 1942, the plant had increased its workforce by 45 percent, and the entire facility was devoted to the war. Around the clock, workers produced steel castings for a variety of war products, including rockets, bombs, and combat vehicles.

77

Employees, family, and friends of the Macklin Company enjoyed a picnic at Clark Lake on July 11, 1934. The Macklin Company made grinding wheels and abrasive products, selling most of its goods with special orders and employing approximately 400 workers. Many companies rewarded their employees with a day out by the lake and a picnic lunch.

This is another image of the Macklin Company picnic held at Clark Lake on July 11, 1934. On April 26, 1945, Macklin employees sued the company for $1.5 million as overtime compensation and liquidated damages, plus costs and attorneys' fees under the provisions of the Fair Labor Standards Act of 1938, citing unpaid overtime worked.

Around 1900, the Hanover community comes out to prepare for a homecoming parade. Many homecoming celebrations included races, bands, picnics, and games. (Courtesy of the Hanover Historical Society.)

In this photograph taken at the 1920 Concord Fourth of July parade and labeled "the long and the short," citizens show their sense of humor and patriotism. The Fourth of July celebrations included many family picnics and races as well as baseball games and fireworks. (Courtesy of the Hubbard Memorial Museum Foundation.)

The cast of a womanless wedding is pictured here in the Concord Opera House. Womanless weddings were popular fundraising events, often hosted by men's civic and social clubs to support a local charity. These plays were entertaining for the community since they featured an entirely male cast. The general idea was a pretend wedding with men dressed as the bride, bridesmaid, flower girl, and the mother of the bride. Usually, the most masculine of men would play the bride. The performance would proceed with a pretend wedding and the arrival of an ex-girlfriend to cause a chaotic and hilarious scene. The community enjoyed seeing their male neighbors prancing about in absurd female costumes, and such events are still popular today as fundraisers. (Courtesy of the Hubbard Memorial Museum Foundation.)

The Wolf Lake Casino and Pavilion, funded by William A. Boland, opened in March 1900. Four stories high and projecting out over the water of Big Wolf Lake, it was a popular weekend getaway. The lower story had slips for boats to load and unload. The second story had fine dressing rooms, a dining hall, and a lunchroom, and the third story had a dance floor and concert hall. The roof had a formal flower garden for promenades. The interurban cars would run every hour from the city of Jackson to the casino—a 20-minute ride. The casino was destroyed by fire in September 1913. (Courtesy of David Raymond.)

Millen Resort on Wolf Lake, owned by Chan Millen, offered lodging, boating, and clean beaches. The resort was completely destroyed by fire in May 1894. It reopened with a new owner, William K. McIntyre, in June 1914. Renamed Mack Island, it offered a dance pavilion, 50 completely redecorated rooms, boating, bathing, fishing, bowling, and billiards. Room and board was available at either single or en suite rates from $2.50 per day, or $12 per week. In the early 1930s, Clara Avrunin bought the resort. Cabins for children were erected on the property, and a regular children's camp was started with about 150 campers. This image dates to about 1890. (Courtesy of the Jackson District Library.)

People gathered on opening day of the Pleasant View Hotel at Clark Lake in 1891 with a drum-and-trumpet band. Tom Beech purchased the land and called it Pleasant View because it sat high on a hill overlooking the water and had panoramic views both up and down the lake. Hotel rates were $1.50 for a room without meals. Because of growing popularity, the hotel was enlarged to accommodate demand. Clark Lake, southeast of Jackson, is famous for its crystal-clear waters and wooded shores. Pleasant View was one of the most popular resorts in southern Michigan.

Bartlett's Resort was located on the northeast shore of Pleasant Lake in Henrietta Township. It was at its height of popularity from the 1940s through the 1960s because of appearances by great bands such as Bill Haley & His Comets and Glenn Miller and his orchestra. In the early days of Motown, the Supremes, Stevie Wonder, Smokey Robinson & the Miracles, the Four Tops, and the Temptations all played Bartlett's. The resort survived a couple of fires through the years but was demolished on June 7, 2006.

In this photograph of a Parma first aid class, Merriman Hendershot is instructing students in artificial resuscitation. Also pictured are J. Cunningham, ? Tribby, Percy Smith, L. Foruor, H. Woodliff, C. Southwell, and Gordon Sanford. (Courtesy of the Parma Township office.)

Six
Depots

The first train depot in Jackson was later a store that sold coal, stoves, and wood. Michigan Central Railroad built this depot in December 1841. As Jackson prospered and traffic increased, the small wooden depot was no longer large enough. (Courtesy of Jackson District Library.)

The present railroad depot opened in 1874 at the corner of Michigan Avenue and Louis Glick Highway. Originally, the station's interior waiting rooms were finished in black walnut, with crystal chandeliers overhead. When finished, it was considered one of the finest depots in Michigan. The station is still in use today. (Courtesy of Jackson District Library.)

The Michigan Central built tracks through Grass Lake in 1842. The Grass Lake depot was designed and constructed by Spier & Rohns in 1887 in the Richardson Romanesque style, which was popular for railroad stations in the 1880s. The depot continued with rail service until 1956 and later became the offices for the *Grass Lake News*. In 1980, a fire destroyed the structure, and the ruins sat for nine years while a community group tried to buy it for rebuilding. In 1988, the Whistlestop Park Association was able to buy the building and also received a grant to help with its restoration. It was rededicated in September 1992 and is now a popular community center. This photograph is from the early 1900s. (Courtesy of Judy McCalsin.)

Brooklyn recognized how important railroad service would be to its future growth; the railroad came to Brooklyn in 1870 because of the influence of store owner Addison P. Cook and newspaperman Joseph M. Griswold. This photograph dates to around 1900. (Courtesy of Mickey Hardcastle.)

Concord Depot appeared on the Michigan Central Railroad in 1850, but by 1873, its name was changed to North Concord. It was 89.2 miles from the depot in Detroit. (Courtesy of the Hubbard Memorial Museum Foundation.)

The Hanover Train Station was built in the early 1870s and was used until the 1940s, when passenger service ended. This 1907 postcard features the Hanover Union Depot. (Courtesy of the Hanover Historical Society.)

Napoleon Depot was built in the late 1850s and was used for both freight trains and passenger trains. It is now part of the Napoleon Feed Mill. (Courtesy of Dan Cherry.)

A Lake Shore & Michigan Southern Railway train passes the icehouse in Norvell. The icehouse was demolished in 1929. (Courtesy of Dan Cherry.)

Parma was originally named Groveland because of a grove of trees, but it was also called Cracker Hill. Many of the early citizens were Quakers. The name was changed in 1862 when it received its post office and was named after Parma, New York, where some of its early citizens had come from. The Michigan Central Railroad extended to the town of Parma in the spring of 1844.

This is the depot in Wheelerton, Michigan. The community was later renamed Pulaski after Count Casimir Pulaski, a Polish hero in the American Revolution. The location of Pulaski was first settled by Reuben Penogen Matthias and Enoch Fisher; the two were originally from Pennsylvania and arrived in 1833. The original settlement of Pulaski was a mile west of the present corners of Folks and Watson Roads but moved closer to the depot when the railroad came through. Enoch Fisher died on November 20, 1885, at the age of 69.

Seven
PEOPLE AND PLACES

Horace Blackman was the first to purchase land and settle his family in Jackson. He and his scouting party arrived at the bank of the Grand River on July 3, 1829. Blackman, from Tioga County, New York, staked his claim on the land and came back a year later with a few other settlers. (Courtesy of the Jackson District Library.)

The first settler in the Hanover area was James O. Bibbins. Bibbins walked from New York to Hanover, Michigan, to claim his land, then journeyed back to New York to collect his wife, infant son, brother, and father. They made their way back to Michigan with three wagons full of a year's worth of supplies, traveling 25 miles day. James Bibbins later built a frame home at 310 West State Street. The Bibbins family of Hanover is pictured here in 1864. (Courtesy of the Hanover Historical Society.)

Pictured here are, from left to right, John Barton, John Oyer, and John Comstock. Springport was founded by John Oyer in 1836 and was originally called Oyers Corner. It developed around the Lake Shore & Michigan Southern Railroad, which arrived in 1876. John Oyer, born in Pennsylvania on January 9, 1819, helped to organize the township government. He died on January 20, 1889. John Barton was born in New York on June 14, 1813, and traveled to Springport with his wife, Elizabeth, by canal and steamboat. He had a farm of 320 acres, and he died February 12, 1890. John Comstock was born in Connecticut on February 20, 1801. He was a teacher until the fall of 1830, when he came to Michigan and married Ruth Eastman. They had four children: Rhoda, Maria, and two boys who died young. Comstock died at the home of his daughter on February 16, 1891. (Courtesy of the Albion District Library.)

William A. Foote, pictured in 1886, was the founder of the Commonwealth Power Company. He was born June 9, 1854, and was raised in Adrian, Michigan. In the 1880s, he became interested in electricity. William and his brother James came to Jackson to install electric lighting in the downtown area. William completed a dam on the Kalamazoo River and was able to transmit electricity more than 20 miles from the city of Kalamazoo. By 1907, the headquarters for the Commonwealth Power Company was in Jackson, and after a series of mergers involving other local electric, gas, and transportation enterprises, the company incorporated as Consumers Power Company in 1910. William A. Foote died April 14, 1915, in Jackson, Michigan. Shocked at the conditions of the hospital where William died, his wife, Ida Foote, donated the former Peter B. Loomis estate for the development of Foote Memorial Hospital, which is now called Allegiance Hospital.

Willey Filley was picking berries when he was kidnapped by the Potowami Tribe in 1837 at just four years of age. He returned to Michigan Center 29 years later. Filley lived with many different Native American tribes all over the United States and later wrote a book about his adventures called *The Indian Captive of the Long Lost Jackson Boy*. Several people claimed to be Willey Filley, seeking fame and fortune. Willey was identified as the real Willey Filley by his uncle, who knew about a scar on his thumb. Filley died around 1900 in the Jackson County Infirmary.

Spring Arbor University was founded in 1873 by leaders of the Free Methodist Church. The early Free Methodists supported freedom for slaves. By 1863, Edward Payson Hart began evangelistic assemblies in Michigan and became the driving force behind the establishment of Spring Arbor Seminary, an academy for elementary and secondary grades. Located near the site of a former Potawatomi Indian village, Spring Arbor Seminary was open to all children, regardless of religious convictions or beliefs. (Courtesy of Spring Arbor University archivist Susan Panak.)

This photograph, dating to the 1882–1883 academic year, shows students and staff of Spring Arbor Seminary—an academy for elementary and secondary grades that was founded in 1873 by leaders of the Free Methodist Church, particularly Edward Payson Hart. It later became Spring Arbor University. (Courtesy of Spring Arbor University archivist Susan Panak.)

In 1929, the school changed its name to Spring Arbor Seminary and Junior College. Entry-level and intermediate courses were no longer available the following year. In 1960, the school earned accreditation, and the trustees changed the name to Spring Arbor College. The high school program was also dropped, and Spring Arbor launched its four-year program just three years later. (Courtesy of Spring Arbor University archivist Susan Panak.)

James Alton McDivitt (a retired brigadier general of the US Air Force) is pictured at the Jackson Rose Parade in 1965. Born June 10, 1929, he is a former NASA astronaut who flew in the Gemini and Apollo programs. He commanded the Gemini 4 flight, during which Edward H. White performed the first US spacewalk, and later commanded the Apollo 9 flight, which was the first manned flight test of the lunar module and the complete set of Apollo flight hardware. He later became manager of Lunar Landing Operations and was the Apollo spacecraft program manager for Apollo flights 12 through 16. Other astronauts who called Jackson home were Al Worden, Jack Lousma, and Allan Bean.

Leonard Hamilton Field (seated at left), founder of the L.H. Field Company department store in Jackson, Michigan, poses with his family around 1900. He was born in 1869 in Massachusetts. His son William (standing center) took over the department store in 1915.

Peter B. Loomis was one of Jackson's most important bankers. He moved to Jackson in 1843 and started a dry-goods business; he later became the owner of the Kennedy Mills. In 1856, Loomis became a partner in a local banking firm, which became known as P.B. Loomis & Company. He also helped in the organization of several Jackson railroads, was elected a member of the state legislature, and served as one of Jackson's mayors. This photograph of Loomis was taken in 1890.

Hibbard House (Hotel), located at the southwest corner of Michigan Avenue and Francis Street, was Jackson's first large hotel building. In 1869, the Hibbard House had new landlords—Mr. Robinson and Mr. Pantlind—who remodeled the entire hotel and built an addition. Many important social functions and events were celebrated in the hotel, which later became the Otsego Hotel. In October 1903, workmen were reconstructing the Ostego Hotel to be one of the finest in the state of Michigan when they were suddenly buried under hundreds of tons of brick and stone; one man, Henry Giltner, died. This photograph dates to around 1895. (Courtesy of the Jackson District Library.)

John George Hall was named after the editor and publisher of Jackson's first junior college. It was built by Francis A. Shaughnessy as a home for his family at a cost of $1 million in 1929. The Shaughnessys imported materials and furniture from Europe, including Belgian tapestries. Mrs. Shaughnessy had an Italian artist live in the home for a year. His artwork is spread throughout the home in the plaster carvings on ceilings and walls. It became John George Hall for the Jackson Junior College on February 16, 1947. (Courtesy of Jackson College.)

Jackson County Poor House, located on County Farm Road west of Airport Road, was once home to the county's poor, homeless, and infirm. Originally built in 1839, it was one of the first poor houses in the early days of Michigan statehood. Fire destroyed the original building in 1886, killing five people. A new wooden frame building with a brick exterior was erected a year later. That structure burned in 1967 in a blaze that was started accidentally by those commissioned to demolish the building. (Courtesy of the Jackson Genealogy Library.)

These residents are working on a project at the Jackson County Poor House. According to the 1881 *History of Jackson County*, 33 people lived in the facility. Although the building does not stand anymore, the cemetery is still there. (Courtesy of the Jackson Genealogy Library.)

The Merriman house, located at 333 West Main Street, was built in the Italianate style in 1860. Mary W. Merriman, mother of Ella Sharp, lived in the home for about 10 years. Here, Howard Merriman (Ella's brother) stands with his horse and buggy in front of the house around 1883. Howard was a popular bachelor in the Jackson area, and had an active social life. He died at the Merriman home on August 4, 1893, at the age of 29, from consumption. After Howard's death, his father, Dwight Merriman, contested his will on the grounds that Howard had been mentally unstable. Howard had left his entire estate to a number of beneficiaries in Jackson. The case went all the way to the Supreme Court, which agreed with the circuit court that Howard was not delusional when he made his will, and the money went to the beneficiaries.

Michigan State Prison, or Jackson State Prison, which opened in 1839, was the first penitentiary in the state. The first permanent structure was constructed in 1842. In 1926, the prison was relocated to a new building, and it soon became the largest walled prison in the world, with nearly 6,000 inmates. (Courtesy of David Raymond.)

Prior to World War I, the Red Cross introduced its first aid, water safety, and public health programs. With the outbreak of war, the organization experienced phenomenal growth. The Red Cross staffed hospitals and ambulance companies and recruited registered nurses to serve the military. Additional Red Cross nurses came forward to combat the worldwide influenza epidemic of 1918; the Red Cross nurses' station at the Jackson County fairgrounds is pictured here in 1918. (Courtesy of David Raymond.)

The Victorian-style home of William Dolville Thompson was built in 1875. Located at 406 North Blackstone, on the northwest corner of Blackstone and Van Buren, it later became the St. Joseph Home for Boys, where Thomas S. Monaghan (founder of Domino's Pizza) lived briefly as a boy. William Thompson started a store in Jackson in 1831. He was elected clerk in 1837, and in 1841 was appointed freight-and-passenger agent until the railroad was sold by the state. After arriving in Jackson, he was blinded by sumac, but the condition was finally cured by a Potawatomi woman with a medicine consisting of bark and roots. Years later, he became a banker and married Alma M. Mann in 1856. (Courtesy of the Jackson District Library.)

The Woodmen's Lodge built the present structure of the Concord Opera House in 1900. It was used not only by various lodges but was also rented out for shows, dances, and community programs. For years, the basement was used as a recreation center for billiards and cards. After the Concord school burned in 1943, the opera house was used for classes and basketball until the new school could be built. In 1953, the building was purchased and remodeled to serve the Roman Catholic parish in Concord. It is now a branch of the Jackson District Library. (Courtesy of the Hubbard Memorial Museum Foundation.)

The best-known attraction of this 465-acre park is the Cascades, a man-made, illuminated waterfall with musical accompaniment that has been enjoyed by all since 1932. The William and Matilda Sparks Foundation, a nonprofit organization, was begun in the fall of 1929 with the purpose of developing this land into a recreation spot and meditation center. The original trustees were William and Matilda Sparks and their two sons, Harry and Clifford.

The Cascades, built in 1932, were the idea of William Sparks to do something for the people of Jackson and to build an attraction that would provide visitors with a positive feeling of the city. This park occupies 465 acres and contains the illuminated Cascades, a giant waterfall, and six fountains over which water tumbles in continually changing patterns. There also is a small museum depicting the history of the Cascades, golf courses, a picnic area, a playground, gardens, a basketball court, and ponds.

This is a photograph of the Ariss family in front of their home in Concord. The house was built in 1841. Thomas Ariss and his wife, Myra B. Blinco, moved to Concord when their son Walter was a year old. Their daughter Myrtle died in infancy, and another son, Gaylord, died at the age of 29. A few years after moving to Concord, Thomas Ariss bought a draying business (a dray is a low, strong cart without fixed sides, used for carrying heavy loads), then later started a livery business. Thomas Ariss had many interests; he served in public office, was deputy sheriff in Concord for many years, and was a member of the village council. He and his wife also managed the hotel at two different times. (Courtesy of the Hubbard Memorial Museum Foundation.)

Pictured is Stephen Hubbard Jr., born April 7, 1824, in New York. He and his wife, Hannah Robinson Baker, made their way to Michigan in 1855 with his father and his second wife. They stopped in Litchfield, Michigan, because they found coopering (barrel-making) work there. Stephen's father and his family moved to Wisconsin, while Stephen and his family made a home in Concord, Michigan. Every day, Stephen Hubbard walked to Litchfield for his job until he and his eldest son, Harvey, purchased a farm, and the family relocated to Pulaski Township. (Courtesy of the Hubbard Memorial Museum Foundation.)

Chauncey "Chan" Wetmore bought several hundred acres of land in Pulaski Township, just south of Concord at the east end of Swains Lake. On the east side of the road, opposite the lake, he built a large, elegant, three-story Victorian-style home as well as extensive barns and outbuildings. This is Chan and Cornelia Wetmore's 50th wedding anniversary dinner. They had two sons, Jean and Earl, and four daughters, Jessie, Lena, Nora, and Cora. Earl Wetmore was a successful engineer who designed subway systems for London, England, and Rome, Italy. He retired and returned to the family farm on Swains Lake, the only member of the family to return. Upon his death, he left no heirs to bear the Wetmore name. (Courtesy of the Hubbard Memorial Museum Foundation.)

The original land of the Spratt house was a 160-acre US land grant to June Humphrey. In the fall of 1872, William H. Spratt and his wife, Mary, purchased the land from Samuel Malcolm, and the house was built in 1876. The Spratts both died in the home, as did their only child, Emma. Mary's brother Henry Bullock inherited the house after her death in November 1900. (Courtesy of the Hubbard Memorial Museum Foundation.)

John and Sarah Mock and their five sons drove into Oyer's Corners (Springport) on October 10, 1865, making the trip from Ohio in two covered wagons drawn by two teams of horses. John Mock came into possession of this 80-acre property on April 6, 1866. (Courtesy of Jackie Merritt, Springport librarian.)

There is not much known about this group of Spring Arbor pioneers, but they may have been part of the Jackson County pioneer group. One pioneer from Spring Arbor was Ambrose Bean, who was born in Spring Arbor in 1831. In 1881, William Todd from Spring Arbor was elected as an officer to the County Pioneer Society. (Courtesy of Spring Arbor University archivist Susan Panak.)

This is the first pioneer picnic of Hanover-Horton, held in September 1894; the last pioneer picnic was held in 1912. The life of a pioneer was difficult. Getting to one's land was a constant struggle as there were not many roads and the roads and trails that did exist were muddy and rocky. There were no bridges, which made crossing even the smallest creek a problem, especially when traveling with oxen pulling wagons of supplies. Fallen trees, getting lost, and wild animals also caused problems. Once the family got to their land, they made a shanty to live in until their log cabin could be built. (Courtesy of the Hanover Historical Society.)

This portrait of the Mann family was taken in 1885, a year after they moved into their home in Concord. Daniel Sears Mann and his wife, Ellen Keeler Mann, had three daughters. The youngest girl, Dolley, died in 1882. In this picture are Jesse Ellen Mann (left, born in 1877) and Mary Ida Mann (born 1874). (Courtesy of Debbie Zeiler.)

After Daniel Sears Mann died in 1905, Jesse managed the family farm. She probably did this for some time before she was eventually able to transfer the management of the farm to an uncle. Here, she is in a buggy with the overseer of the property and Jenny the horse, ready for a trip to the farm. (Courtesy of Debbie Zeiler.)

This photograph is of the women of the Mann family of Concord. Although not all of their names are known, the mature woman sitting at the piano is more than likely Ellen Keeler Mann, and Mary Ida is probably the woman near the bottom left of the photograph, looking at the little boy. (Courtesy of Debbie Zeiler.)

Edward Payson Hart was born June 6, 1835, in Middlesex, Vermont. After marrying Martha Bishop on August 8, 1860, in McHenry, Illinois, the Reverend Hart became a pastor with the Methodist Episcopal circuit. In 1861, he was influenced by a meeting with the founder of the Free Methodist Church, Rev. Benjamin Titus Roberts, and quickly became a Free Methodist minister. In 1863, he was asked to work in Michigan, and a decade later, Reverend Hart founded a coeducational private high school known as Spring Arbor Seminary. He died at the age of 81 on March 15, 1919. (Courtesy of Spring Arbor University archivist Susan Panak.)

Charles Elroy Townsend was born near Concord, Michigan, on August 15, 1856. He taught school at Concord from 1881 to 1886. He studied law and, in 1895, started a law practice in Jackson. Townsend was elected as a Republican to the US House of Representative for three succeeding Congresses, serving from March 4, 1903, to March 4, 1911. He was elected to the US Senate in 1910 and was reelected in 1916, serving form March 4, 1911 to March 4, 1923. He was an unsuccessful candidate for reelection in 1922. Townsend was appointed in 1923 as a member of the international joint commission created to regulate the use of the waters between Michigan and Canada. He died on August 3, 1924, and is interred in Concord's Maple Grove Cemetery.

There were five main coal mines in Jackson County—the Jackson, Woodville, Sandstone (pictured here), Hayden, and Reynolds Mines. Mines employed over 1,000 workers in the peak years around 1880. Michigan coal, which was soft and black, was useable for home heating but did not meet the fueling needs of industry.

Ella Merriman Sharp was born February 14, 1857, along with her twin brother, Frank, who died at the age of four in 1861. Ella Sharp was known throughout Michigan for her work in forestry and civic improvement. Although she suffered from various health issues, it never stopped her from achieving various accomplishments with the Michigan Federation and National Federation of Women's Clubs. As chairperson of the Michigan Federation's Forestry Committee, Sharp led a statewide crusade to establish state forest preserves and a fire-watch system. In 1909, she was the only woman invited to speak to the all-male Michigan Forestry Association at their annual meeting. In addition to leading the Forestry Committee, Sharp was also the chair of the Civic Improvement Committee of the Federation of Women's Clubs.

Merriman-Sharp Hillside Farm was purchased by Ella Sharp's grandfather Abraham Wing. Her parents, Dwight and Mary Wing Merriman, added on to the structure over the course of almost 20 years to accommodate their family. Ella and her husband, John Sharp, lived in the home after their marriage and until their deaths. When Ella died in 1912, she left the house and its property to the city of Jackson to be converted into a park; it was subsequently named the Ella Sharp (or just "Sharp") Park.

This photograph shows Ella Sharp on the front porch with one of her dogs. Ella loved the home that she had grown up in and loved the farm life, including gathering eggs and riding and breeding horses. On October 22, 1998, Ella Sharp was inducted into the Michigan Women's Hall of Fame.

In this image, Ella is holding John Sharp's picture after his death in 1908. John Sharp was 60 years old when he died and had been a dedicated husband, farmer, and Michigan Republican. He was an alternate delegate to the Republican National Convention from Michigan in 1884. He is buried at Mount Evergreen Cemetery. Ella, who was 51 at the time of John's death, was the last of her family. Ella died from kidney failure on November 9, 1912.

Della Thompson Lutes was born in 1872 to Elijah and Almira F. Bogardus Thompson in Jackson. She graduated from Jackson High School and began teaching at the age of 16 for the Jackson County School District. She gained much local interest for her book *Just Away*, as well as for several articles she wrote for Detroit newspapers. In 1907, Della moved to Cooperstown, New York, to become the editor of a ladies journal called *American Motherhood*. She later became editor of *Table Talk* and *Today's Housewife*. In 1924, Della became housekeeping editor and director of the *Proving Plant of Modern Priscilla* in Boston, Massachusetts. From there, she went on to become an acknowledged expert on housekeeping topics.

On July 6, 1893, Della married Louis I. Lutes in Detroit. Together, they had two sons, Robert and Ralph. Della Lutes's best-selling book *Country Kitchens* was published in 1936. Several other popular books followed, including *Home Grown* (1937), *Mill Brook* (1938), *Gabriel's Search* (1940), and *The Country School Ma'am* (1941). She wrote *Cousin William* in 1942. Della died on July 4, 1942, of a heart attack. (Courtesy of the Jackson District Library.)

Col. Charles Victor Deland was born July 25, 1826, in North Brookfield, Massachusetts. Deland was an accomplished man—a Civil War officer, one of the founders of the Republican party, and the starter of the *Jackson Citizen* newspaper midway through the 19th century. He subsequently served in the Michigan state senate in 1861 and held other political offices. At the start of the Civil War, Deland organized a company in late December 1862. He was promoted to colonel of the 1st Michigan Sharpshooters and was wounded in battles, including an 1862 incident at Murfreesboro, Tennessee, where he was captured by the enemy and spent five months in prison. After the war, Deland returned to Michigan and became a newspaper editor. In 1903, he compiled *The History of Jackson County*, which remains a standard Jackson historical reference today. (Courtesy of the Jackson District Library.)

Austin Blair (February 8, 1818–August 6, 1894), also known as the "Civil War Governor," was a lawyer and politician from Jackson. He was known as a strong opponent of slavery, and he also supported human rights by leading the fight to ban capital punishment and by supporting efforts to give women and black citizens the right to vote. He was the 13th governor of Michigan, and was the first state governor to respond to Pres. Abraham Lincoln's call for troops to fight in the Civil War. While Michigan's 3rd and 4th regiments were being raised, Blair was told by the US secretary of war that only four Michigan regiments would be needed. He overlooked that message and continued to establish the 5th, 6th, and 7th regiments, all of which were deployed by mid-September. Unlike other politicians of the time, Blair had no personal wealth. He was paid $1,000 a year as the governor of Michigan, and when he left the office, he was almost destitute, having spent much of his money in the course of the war. (Courtesy of the Jackson District Library.)

Austin Blair lived with his family in a white house surrounded by a white picket fence at 120 Lansing Avenue around 1851. The property was bought in 1913 by the Sisters of Mercy, who tore it down to build Mercy Hospital. Austin Blair is the only Michigan governor to have a statue on the front lawn of the Michigan state capitol. When it was dedicated on October 12, 1898, the *Jackson Semi-Weekly Citizen* reported that it took 18 railroad cars to carry the Jackson crowd to Lansing. Once there, the group marched in a parade led by Jackson's noted Boos Band.

Eight

WARS AND MILITIA

This photograph of Camp Blair is believed to show soldiers in formation for services shortly after the assassination of Pres. Abraham Lincoln. Notice the flags are at half mast. Named after Gov. Austin Blair, a Jackson resident, it was built to house 2,500 soldiers. Established on land owned by the Hibbard family, the 11-acre camp comprised offices, a hospital, barracks, and storehouses. The first troops arrived in the spring of 1864. Camp Blair was planned as a draft meeting site and as a center for convalescing troops. In June 1866, Camp Blair was closed and approximately 5,000 people left the city. The location of Camp Blair was lost until members of the Sons of Union Veterans researched the site in 2006 and discovered that it was located at 1212–1214 Wildwood Street. A historical maker documents the site.

The Jackson Greys were in existence prior to the outbreak of the Civil War. The company was organized and equipped under the leadership of Capt. William M. Bennett in 1856. With a militia readied in a time of peace, they were prepared for the war.

The Jackson Greys are pictured with Capt. D.C. Sauer at camp. Upon returning to Jackson, the veterans came home to the third-largest city in Michigan. The Jackson Greys fought from Bull Run to Appomattox, and the veterans returning to Jackson saw many changes during the 1870s, with frame houses replacing log cabins, cobblestone streets replacing mud paths, and industries and manufacturing replacing agriculture.

The 17th Infantry was established in Jackson and adjoining counties in August 1862 under the call for 600,000 men issued after the battle of Bull Run. It contained three companies from Jackson County and was commanded by Col. William Herbert Withington. It was attached to the 9th Corps and fought in 30 battles. After the war, Col. William Withington became a successful businessman, owning Withington, Cooley & Company and manufacturing agricultural equipment. He served in the Michigan state legislature as a representative of Jackson County from 1873 to 1874. Later, he funded a sculpture in honor of the soldiers of the 1st and 17th Regiments. This memorial is located in Withington Park at 410 West Michigan Avenue. This reunion photograph of the 17th Infantry was taken around 1880.

On July 7, 1865, Civil War colonel Christian Rath was given the responsibility of hanging the conspirators of the Lincoln assassination. Rath is the man in white putting a noose over one of the conspirators. Those executed were George Atzerodt, David Herold, Lewis Payne, and Mary Surratt, who was the first woman sentenced to death by the federal government. Captain Rath made the nooses and hoods the night before. He never talked about the executions until 46 years later, when he expressed guilt for his part in them. Captain Rath also identified the body of John Wilkes Booth, having known him for 15 years. Captain Rath died on February 14, 1920, at age 89. (Courtesy of David Raymond.)

Grand Army of the Republic Civil War veterans and family are pictured on Main Street in Concord. The Grand Army of the Republic (GAR) was an organization of veterans of the Union army who served in the Civil War. Founded in 1866 in Decatur, Illinois, it ended in 1956 when its last member died. GAR allowed veterans to share their experiences and organize advocacy groups to support voting rights for black veterans and lobby the US Congress to establish pensions for veterans. It reached its peak membership—more than 490,000—in 1890. (Courtesy of the Hubbard Memorial Museum Foundation.)

These Jackson men, members of Companies D and H, 1st Regiment MNG for Island Lake, are marching off to fight in the Spanish-American War on April 26, 1898.

This photograph shows a Spanish-American War camp in Cuba. American public opinion grew angry at reports of Spanish brutalities in Cuba, and although the main issue was Cuban independence, the 10-week war was fought in both the Caribbean and the Pacific. American naval power proved vital, allowing US forces to land in Cuba against a Spanish stronghold already devastated from nationwide rebel attacks and a yellow fever epidemic. The man on the far left is Frank Phelps.

On June 19, 1916, the entire Michigan National Guard was called out for service on the Mexican border, incited by raids on border towns by the Mexican bandit Francisco "Pancho" Villa. This conflict, which became known as the Pancho Villa Expedition, was a military operation led by the US Army against the rebel forces of Villa from 1916 to 1917 during the Mexican Revolution. The official beginning and ending dates of the Mexican Expedition are March 14, 1916, and February 7, 1917. The men in this image are leaving for Mexico on June 24, 1916.

Nine
TRAGEDIES AND DISASTERS

On December 21, 1942, the Oppenheim's store was damaged by a fire. Firefighters pumped water on the blaze for nine hours and spent thirty-five hours battling the flames. A faulty oil burner was suspected to have been the cause.

Crowds gather to witness the damage to the Oppenheim store, which amounted to more than $500,000. The Oppenheim store was opened in 1898 by two brothers, Louis and Charles Oppenheim. All store inventory was destroyed in the blaze, as were customers' Christmas layaways. Remodeling began soon after the fire, and the new store had its grand opening on February 18, 1948. The store stayed open until it merged with a Detroit-based business in 1964.

William S. Mock's home lays in ruin after a tornado hit at noon on June 6, 1917. Mr. and Mrs. Mock were in the house and uninjured, but their son Stewart was in the granary, which blew down and seriously injured him. Two died in the storm, and 29 were injured in Calhoun, Jackson, and Ingham Counties. The twister devastated the southern part of Springport, destroying about 35 buildings. (Courtesy of Jackson District Library.)

Debris was scattered for miles after the tornado, which continued east and left a path of destruction in its path. Michigan has a history of deadly tornadoes dating back to the late 19th century; since 1882, at least 343 people have been killed in the state by tornadoes. (Courtesy of the Jackson District Library.)

On November 22, 1883, Jacob Crouch was shot and killed in his home along with his pregnant daughter Eunice, her husband Henry White, and friend Mosses Polley. The murderer was never caught, and the event remains a mystery today. This portrait of Jacob Crouch was completed posthumously.

This is the Jacob Crouch home, where four people were murdered during a thunderstorm on November 22, 1893. According to rumor, Crouch was cutting his daughter Susan, son Judson, and Susan's husband Daniel Holcomb out of his will. Susan Crouch died on January 2, 1884, by "supposed suicide." There are many unexplained circumstances surrounding these murders, even now.

The boy's dormitory at Spring Arbor University was destroyed by fire in 1930. The old brick-and-wood structure was built in 1882. The fire started in the attic, and when fire departments from Concord and Jackson came to the scene, it was too late; the brick walls had collapsed. Very little was saved in the fire, but students and staff preserved what they could by throwing books and belongings out the windows. Emergency measures were taken to house the students. The damage was estimated at $40,000. (Courtesy of Spring Arbor University archivist Susan Panak.)

In 1922, the interurban train in Parma was coming around the bend too fast. The brakes failed, and it jumped the track and ran right into the jail. There were 15 people injured, and the driver, Mr. Green, was killed. The jail was completely demolished.

The wrecked greenhouse on the grounds at Southern Michigan Prison bears the marks left by 2,600 rioting convicts. Most of the windows were shattered, potted plants were thrown out, and the plumbing was destroyed. A group of 11 prison guards were held hostage in April 1952 in an uprising that began in cellblock 15—the maximum-security block—and lasted for four days. The riot brought to the forefront new philosophies of prison administration and rehabilitation of prisoners as opposed to confinement. (Courtesy of David Raymond.)

Capt. Earl Secrist of the Michigan State Police surveys the damage at the library of the Jackson Prison in April 1952, after the facility was destroyed by 2,600 rioting convicts. Most of the library had been burned by the rebel inmates, who were led back to their cellblocks by armed troopers. Damage caused by the rioting convicts was estimated at $2.5 million. Jack Hyatt, known as "Crazy Jack," was one of the ringleaders of the incident. In 1953, he was sentenced to 23 years for kidnapping a guard. He was sent to Marquette Prison and served eight years in solitary confinement, and was released in 1962. (Courtesy of David Raymond.)

At 1:00 a.m. on Friday, October 10, 1879, the yardmaster of the Michigan Central's Jackson railroad yard had the yard crew move nine cars and a caboose from the north side of the yard to the south side. The crew had moved onto the main track about a half-mile west of Dettman Road and was starting to bring the cars into the yard when a westbound passenger train came onto Dettman Road and collided into the switch engine. Both engines derailed, along with the first three passenger cars. The accident killed 13 passengers, and 26 more were injured. The Jackson yardmaster was found criminally negligent for not acquiring the time of the passenger train before authorizing the move.

On Friday, October 13, 1893, the Michigan Central was moving nearly a dozen special trains west to the World's Columbian Exposition in Chicago. One special train was stopped at the Jackson station, and as it was preparing to depart, another train slammed into the rear car. The engineer claimed the air brakes failed but was still found at fault. As a result, 14 people died in the crash, and 70 more were injured.

On July 13, 1913, a train wreck occurred a half-mile west of Francisco. Engineer James S. Martin of Detroit was killed and was buried beneath the engine. The fireman, Clayton E. Cole of Jackson, was scalded by escaping steam and later died. There was an inquest into the wreck, but the cause was never clear. (Courtesy of the Grass Lake Historical Society.)

Discover Thousands of Local History Books
Featuring Millions of Vintage Images

Arcadia Publishing, the leading local history publisher in the United States, is committed to making history accessible and meaningful through publishing books that celebrate and preserve the heritage of America's people and places.

Find more books like this at
www.arcadiapublishing.com

Search for your hometown history, your old stomping grounds, and even your favorite sports team.

Consistent with our mission to preserve history on a local level, this book was printed in South Carolina on American-made paper and manufactured entirely in the United States. Products carrying the accredited Forest Stewardship Council (FSC) label are printed on 100 percent FSC-certified paper.

MADE IN THE USA